IMAGES
of America

KIDO
BOISE'S FIRST RADIO STATION

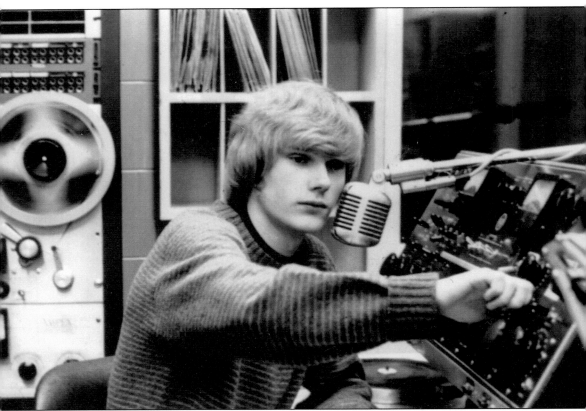

This 1971 photograph shows author Art Gregory operating a vintage RCA control board while working as an announcer at age 18 for KBOI AM-FM-TV. He always wanted to work for KIDO but lacked the necessary first class license required by the Federal Communication Commission to operate a radio station with a directional antenna. A change in the operator requirements allowed him to finally realize his dream, and he worked for KIDO as a staff announcer from 1975 to 1976. (Courtesy of the author.)

ON THE COVER: This late-1940s image shows several KIDO announcers discussing a script in the main studio on the mezzanine of the Hotel Boise. The KIDO announcing staff included, from left to right, Gene Perkins (back cover), Joe Maggio, Hal Stewart, and Vern Moore. (Courtesy of Vern Moore.)

IMAGES
of America

KIDO
BOISE'S FIRST RADIO STATION

Art Gregory

ARCADIA
PUBLISHING

Copyright © 2012 by Art Gregory
ISBN 978-0-7385-9511-5

Published by Arcadia Publishing
Charleston, South Carolina

Printed in the United States of America

Library of Congress Control Number: 2012932000

For all general information, please contact Arcadia Publishing:
Telephone 843-853-2070
Fax 843-853-0044
E-mail sales@arcadiapublishing.com
For customer service and orders:
Toll-Free 1-888-313-2665

Visit us on the Internet at www.arcadiapublishing.com

*This book is dedicated to my family, Harry Redeker, Kiddo
Phillips, Georgia Davidson, Vern Moore, the History of Idaho
Broadcasting Foundation, and Idaho broadcasters everywhere.*

CONTENTS

ACKNOWLEDGMENTS

This book would not be possible without the help and encouragement of Kristi Krueger-McEntee, granddaughter of Georgia M. Davidson; Frank Aden Jr.; Vern and Lorraine Moore; Jessica and Richard Shedd; Jack J. Link; James A. Johntz Jr., his son, Andy, and wife, Willa; Kevin Godwin; Cindee Scholfield; Lucas Babin and Leland Eichelberger of Peak Broadcasting; Vera Cederstrom; Gilbert Rose Jr.; Jim Blossey; Del Chapman; Dick McGarvin; Jack Thompson; Larry Taylor; Rockwell Smith; R.W. Egelston; Larry Cain; and the members of the History of Idaho Broadcasting Foundation.

Erica Flitton, Rod House, Steve Barrett, and others at the Idaho State Historical Society have been incredibly helpful, along with my editor, Coleen Balent, of Arcadia Publishing. However, I especially want to thank longtime KIDO employee and broadcast pioneer Vern Moore. When Moore moved to Hayden, Idaho, in 2002, the realtor handling the sale of his Boise home was my nephew, Andrew Bender. When Moore realized that I was the Art Gregory who had worked with him at KIDO, he told my nephew he wanted to give me some historical items. What I received was his complete history of KIDO, including many black-and-white photographs you are about to see for the first time. Many others have also helped with vintage photographs and documents, especially Frank Aden Jr., and Bill Harms of Elk Ridge, Maryland, who scanned many of the early KFAU and KIDO records from the Broadcast License Files Repository at the National Archives in College Park, Maryland.

Finally, I wish to acknowledge the support of my parents, Quinten and Helen Gregory; my beautiful wife Patty; my brother Marty Gregory, who scanned many of the photographs you are about to see; my sons Jeremy and Michael; and my daughter Isabella for their support and encouragement. I also wish to thank Jim and Rick Zamzow and my boss Darin Eisenbarth for keeping me gainfully employed as the communications and marketing director of Zamzows Inc. for more than 20 years.

Visit the website www.historyofidahobroadcasting.org for more on the history of KIDO and the other radio and television stations that are part of the continuing story of broadcasting in Idaho.

INTRODUCTION

Broadcasting began in Boise on 7YA, Boise High School's technical/training station, which was licensed in early 1920. 7XT was Boise High's experimental shortwave station. The students wanted to broadcast music, weather, and market reports, which was not permitted on those stations. So, in 1922, physics teacher Harry Redeker traveled to Seattle, attended a training session, and obtained a limited-commercial license, which was assigned the call letters KFAU.

Under Redeker's leadership, KFAU improved its facilities and increased its daytime power from five watts to 4,000 watts, and its nighttime power to 2,000 watts. For a time, KFAU was one of the most powerful radio stations in the entire region. It was also one of the first stations west of the Mississippi to broadcast on a regular time schedule. But the expense proved to be too much for the Boise School District, which owned the station, and after Harry Redeker left Boise in the summer of 1928, the school district sold KFAU. The buyers were Frank L. Hill and Curtis G. "Kiddo" Philips, the owners of KORE in Eugene, Oregon, who had also agreed that Phillips and his wife, Georgia, would move to Boise to operate the station. On November 5, 1928, the station's call letters were changed to KIDO to stand for Idaho.

The Phillipses operated KIDO for more than 30 years, until January 31, 1959. During that time, the station progressed from a small operation on the top floor of the Boise Elks Lodge to modern studios and offices in the basement of the new Hotel Boise, which they moved to in December 1930. KIDO upgraded its studio and transmission equipment, and was always looking for ways to serve the community. They announced lost items, found missing children and pets, and helped nab escaped criminals.

In 1935, Vern Moore joined the KIDO staff, staying for 41 years. In June 1937, the station moved to new studios on the mezzanine of Hotel Boise, and on October 1, 1937, it brought NBC to Boise as the state's first network affiliate. On June 20, 1942, "Kiddo" Phillips passed away at the young age of 44, leaving Georgia with two small children and the radio station. In 1946, she remarried, became Georgia Davidson, and went on to build KIDO-FM in 1947. In 1949, she relocated KIDO's studios and offices to beautiful new facilities in the new Chamber of Commerce Building. In 1951, she changed KIDO-AM's frequency to 630 kilocycles and increased its power to 5,000 watts. In 1952, she applied for a television station and built KIDO-TV, signing it on the air in 1953. In late 1958, she decided to concentrate all of her efforts on the new medium of television, so KIDO radio was sold, and a brand new era in KIDO's history began.

The Bill Boeing/Jack Link Era began on February 1, 1959, when the Mesabi Western Corporation bought KIDO radio. The following year, KIDO moved to new studios and offices at 1528 Vista Avenue. Mesabi was the name of the Boeing Family Trust, which was owned by Bill Boeing Jr. From 1959 until 1962, Jack Link was the manager of KIDO in Boise. He then returned to Seattle to become the supervisor of all Bill Boeing's radio stations. In addition to being an excellent manager, Link has always been highly involved in the communities in which he lived. Most

recently, he received the prestigious McNaughton Award from Junior Achievement of Washington on March 29, 2012, in Seattle.

In 1962, sales manager James M. Davidson replaced Link as station manager. Cap Ingalls was named sales manager and served until 1970, at which time Andy Enrico took over. In 1975, Teddi Jones became one of Boise's first female sales managers, serving until 1976, when Pat O'Halloran assumed that job.

Program directors at KIDO during the Mesabi period included Vern Moore (1959–1962), Jim Blossey (1962–1964), Lon Dunn (1965–1972), Lee Johnson (1972–1974), Dennis Dunn (1974–1975), and Ernie Allen (1975–1976). John Maxon was chief engineer from 1959 to 1963 and Don Cederstrom was chief engineer from 1963 to 1976.

Under Mesabi, KIDO evolved into Boise's premier full-service adult radio station. KIDO called its five full-time air personalities the "Live Five." KIDO also became Boise's preferred audio production house, doing production work for clients and agencies such as Davies & Rourke and Albertsons.

In late 1968, KIDO radio moved from Vista to new studios and offices on the fifth floor of the Owyhee Plaza. One consideration in the move was for a more wheelchair-friendly facility to accommodate its newest air personality, Ernie Allen. KIDO had many great announcers during the Mesabi Western era, most of whom had a first class radio telephone permit. However, in 1975, the law changed, allowing third class operators to operate a directional station.

Vern Moore was the best-known of all KIDO personalities because of the number of years he was there. However, announcers like Dick McGarvin, Del Chapman, Jim Blossey, Lon Dunn, Bob Swanson, Jack Thompson (also known as Jack Allen), Bob Christopher, Larry Taylor, Mike Lesh, Straight Arrow, and many others had successful careers on other stations, often in bigger markets. Other KIDO announcers you may remember include J.J. King Valley, Ron Sanford, Jim Bergman, Jack Morgan, Doug West, Marsh Terry, Dennis Dunn, Bob Brenna, Ben Raider, Ken Jewell, Michael O'Shay, Lee Johnson, Bruce Zimmerman, Clark Creamer, Dave Keefer, Art Gregory, Dave Freeman, Pat Rutledge, Dennis Ray Metzger, and Dan Harrison, to name a few.

During the Mesabi Western years, KIDO remembered its roots, and for one week every year, they held Golden Sound Week, playing big band music and old radio shows to celebrate the day KFAU became KIDO, November 5, 1928.

Boeing's involvement in broadcasting, however, would not last forever. Bill Boeing Jr. saw the opportunity to expand into real estate, and warehouses and office buildings were easier to manage than radio stations. In the late 1960s, Mesabi began selling off its radio properties. Jack Link got his real estate license and set out to learn all he could about property management and development. The first radio stations to be sold were KPAM and KPFM in Portland. Then, KETO-AM and FM were sold to separate radio groups. Soon, KIDO was the only radio station Link was involved in managing.

Bill Boeing and Jack Link did not set out to sell KIDO to Western Broadcasting; it just worked out that way. Link said that selling KIDO "was one of the toughest ones to let go of. But at the time, it was the logical thing to do." The Boeing family was doing their estate planning, and with their recent investments in real estate, that was the direction they were going. On July 1, 1976, KIDO was sold to New Executive Motel Inc., owned by Western Broadcasting Company of Missoula, Montana.

The story of how Boise High School's 7YA and KFAU evolved into KIDO is a truly remarkable one that has involved many people. You are about to meet some of those people, and will hopefully come away with a better understanding and appreciation of all they have done over the past 92 years.

One

BROADCASTING BEGINS

IN BOISE

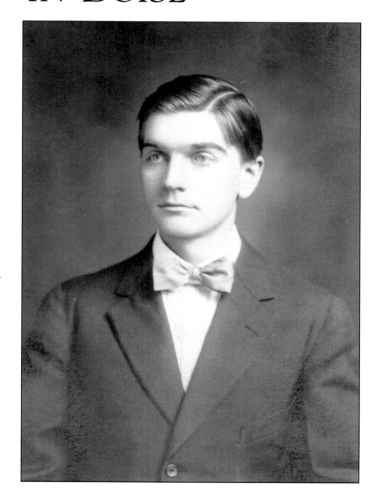

Harry E. Redeker came from Rupert in 1917 to teach physics and chemistry at Boise High. He was also the track coach. In addition, he taught Morse code classes at night for World War I pre-inductees, using a spark set, for which he was paid an extra $400 per year. The school formed an organization called the Sparks Club and built a broadcasting studio under the stage. (Courtesy of the Idaho State Historical Society.)

The US Forest Service loaned Boise High a five-watt radio-telephone transmitter, and in 1920, they obtained a license as 7YA. Among the first broadcasts was the 1920 University of Idaho–University of Utah football game, when both the spark system and the voice system were used. The first known music broadcast was Christmas 1921, and may have happened after school hours. This photograph shows 7YA as it appeared from 1920 to 1923. (Courtesy of the Idaho State Historical Society.)

Boise High applied for a limited-commercial license, and on July 18, 1922, was issued the call letters KFAU, which were assigned alphabetically. KFAU's first broadcast was a sermon and the preacher invoked God's blessing on this new means of communication, predicting that millions of people would hear religious services in their homes someday. Here, Harry E. Redeker (center) is seen on the roof of Boise High with two unidentified men. (Courtesy of the Idaho State Historical Society.)

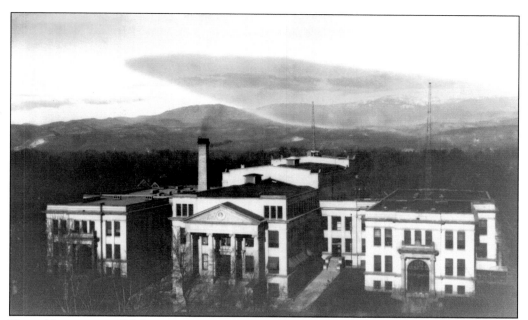

Two self-supporting 125-foot towers were erected on top of Boise High School to send out the signal of KFAU. The antenna was a T-type, using six number-12 copper wires. Local residents did not like KFAU's transmitter being so close to residential Boise, as the station's signal often overpowered distant stations they were trying to listen to. (Courtesy of the Idaho State Historical Society.)

Exactly what these two men are doing up on top of this tower on the roof of Boise High School is not known. However, they do not appear to be scared and they probably had a great view of downtown Boise and the area surrounding the schoolyard. (Courtesy of the Idaho State Historical Society.)

BOISE HIGH SCHOOL
Boise, Idaho

Radio _7C B_ Ur. _C.W._ Sigs. _W.K.D._ Hr. on _5/14/25_ at _____ P.M., M. S. T.

A ud. _Gsa_ Qrm. _little_ Qrn. _____ Qss _____ Qsb. _7G3_

Transmitter _5Q_ Watt

Hartley CKT

1450 Volts on plate

2 Amps. Ant. Cur.

Ctpse. _1 wire_

D.X. _____

7 Y A

A. R. R. L.

Receiver _3_ Tube

Louis Low

Antenna. _Hertz Fan_

Remarks. _Gld to exchange msgs with u om., Especially those pertaining to 7S1, 40 meters is sure great stuff eh what? Hope to be 2so with u anytime. We will always take msgs. & se 2d._

H. H. Fletcher "HF" ←

Best 73's

H. E. Redeker "TOM." K. S. Norquest "K N." H. Burkhart "H B."

Cecil Grow "C G." G. O'Reilley "G O." D. K. Taylor "R Q."

In 1920, 7YA was licensed as an amateur radio station and continued to operate even after KFAU went on the air as a limited-commercial station in July 1922. This was the postcard 7YA sent back to other radio amateurs who picked up its signal. This particular card is dated May 14, 1925, and listed the members of the radio club and their shortened radio air names. (Courtesy of Frank Aden Jr.)

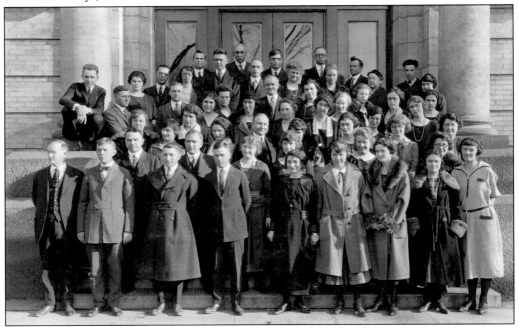

This late-1920s Boise High School faculty photograph appears to be have been taken in front of one of the side doors and shows the staff, with 20 men and 35 women. Harry Redeker is at the top with his head between the opening of the center doors. (Courtesy of the Idaho State Historical Society.)

PROVISIONAL

Form 100

No. 553

LICENSE FOR LAND RADIO STATION

CLASS "A" - LIMITED COMMERCIAL.

DEPARTMENT OF COMMERCE
BUREAU OF NAVIGATION
RADIO SERVICE

RADIO SERVICE
SEATTLE, WASHINGTON
OCT 7- 1925
RECEIVED
DEPARTMENT OF COMMERCE

Pursuant to the act to regulate radio communication, approved August 13, 1912,

INDEPENDENT SCHOOL DISTRICT OF BOISE CITY

a citizen of the State of * * * * * * * * * * * *, a company incorporated under the laws of the State of _____ I D A H O _____, having applied therefor, is hereby granted by the Secretary of Commerce for a period of ___ THREE MONTHS ___ on and subject to the restrictions and conditions hereinafter stated and revocable for cause by him, this License to use or operate the apparatus for radio communication (identified in the schedule hereinafter) for the purpose of transmitting to and receiving from ship stations and other land stations public correspondence, Government and service correspondence, and distress signals and messages, at rates of compensation not in excess of those fixed by the international agreement to which the Government of the United States has adhered, which have been submitted to and approved by the Secretary of Commerce, as included in the schedule hereinafter, or for the purpose of conducting experiments for the development of the science of radio communication or the apparatus pertaining thereto, to carry on special tests, using any amount of power or any wave lengths, at such hours and under such conditions as will insure the least interference with the sending or receipt of commercial or Government radiograms, of distress signals and radiograms, or with the work of other stations, the purpose of the station being designated by the classification at the head of this License.

This original KFAU license, dated October 7, 1925, was issued by the Seattle service office of the US Department of Commerce, Bureau of Navigation. It indicates that KFAU was licensed for unlimited hours of operation at 500 watts using a Western Electric V.T. telephone transmitting on a wavelength of 278 meters, or 1,080 kilocycles. KFAU was a Class A limited commercial station that could broadcast entertainment, market, and weather reports. However, the license stated that no variation from that was permitted. It also stated that an operator holding a first- or second-class commercial license must be on duty at all times, and that KFAU's frequency and hours of operation could be changed at any time by the secretary of commerce, Herbert Hoover, who signed and sealed the document issuing KFAU this license on September 30, 1925. Also noted was that KFAU had been inspected by O.R. Redfern on June 11, 1925. (Courtesy of James A. Johntz Jr. and Andy Johntz.)

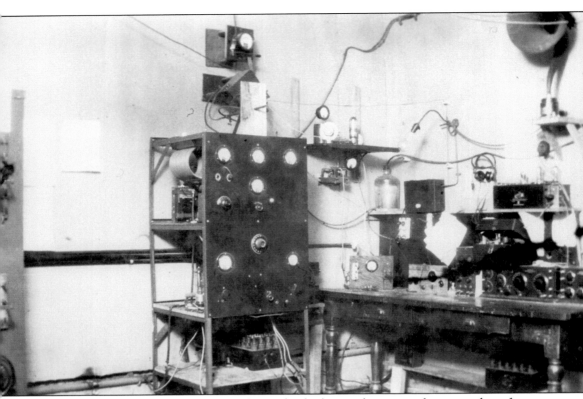

By 1922, KFAU had the most complete radio facility in the state—three soundproof rooms at Boise High School. The estimated value of the equipment and the station license was over $10,000, yet the school had only spent about $600 on the project. Early equipment included a 150-watt power amplifier, a 10-watt transmitter, and a one-half-kilowatt 1,000-volt generator. The students, some of whom were females, built and maintained much of the equipment under their instructor's able direction. Harry Redeker was an inspiring teacher who truly loved KFAU. In fact, in the 1924 Boise High School *Courier* on page 144, there are images of KFAU's studios and control room with the caption, "He can live without chemistry . . . he can live without brew. But poor Harry R . . . cannot live without K-F-A-U." This vintage photograph shows the KFAU transmitter and studio in 1923. Note the large speaker horn at the top. (Courtesy of the Idaho State Historical Society.)

In 1924, KFAU broadcast Sen. William E. Borah's first radio speech, which took place at the dedication ceremonies of the new Boise High School auditorium. Appropriately, the name of the licensee was changed to Boise High School in late 1924. This photograph shows the new auditorium and its large upper balcony. (Courtesy of the Idaho State Historical Society.)

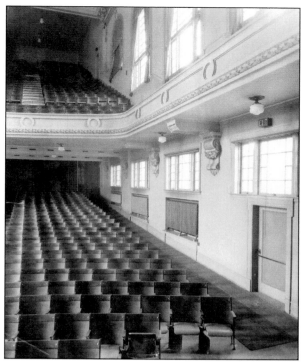

In 1925, Western Electric and Idaho Power helped KFAU obtain more professional equipment at about one-tenth of its normal cost. This photograph shows the lead-in lines at the rear of the auditorium. Across the street is the historic Johnson House, which later became the studios and offices of Boise's KYME-AM and for KIZN-FM, which was licensed to New Plymouth. KIZN signed on the air in March 1982. (Courtesy of the Idaho State Historical Society.)

The students who worked at KFAU saw the station's power and dial position change many times. In late 1925, KFAU moved to 1,060 kHz with 750 watts but had to divide time with KFDJ (now KOAC) in Corvallis, Oregon. In this 1927 photograph, members of the Boise High School Radio Club pose for a photograph on the front steps of the high school. (Courtesy of the Idaho State Historical Society.)

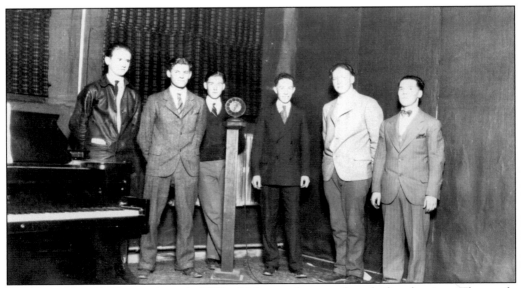

KFAU went to 4,000 watts in early 1927, which was almost unheard of at the time. The newly empowered Federal Radio Commission assigned KFAU to operate at 1,050 kilocycles with 4,000 watts of power until local sunset and 2,000 watts at night. In this photograph from 1927, the KFAU studio gang poses next to the studio piano and the station's vintage microphone, sitting on a homemade stand. (Courtesy of the Idaho State Historical Society.)

For a time, KFAU shared its frequency with another Boise station, KFFB, owned by the Jenkins Furniture Company, which was located at the Owyhee Hotel. In 1925, KFAU expanded its daily broadcast time by 15 minutes from 4:00 p.m. until 4:45 p.m., and to three nights per week. Here is a close-up view of the KFAU transmitter, which was in the basement of Boise High School at the time. (Courtesy of the Idaho State Historical Society.)

In 1926, conductor John Philip Sousa came to Boise and KFAU decided to broadcast his performance. Sousa would not allow it, and asked them to remove the microphone, which they did. However, they had a second hidden microphone for 7XT, the school's shortwave station, and Sousa's concert was broadcast there, getting a reception report from New Zealand. Of course, they could not tell Sousa. This 1927 photograph shows the 7YA transmitter. (Courtesy of the Idaho State Historical Society.)

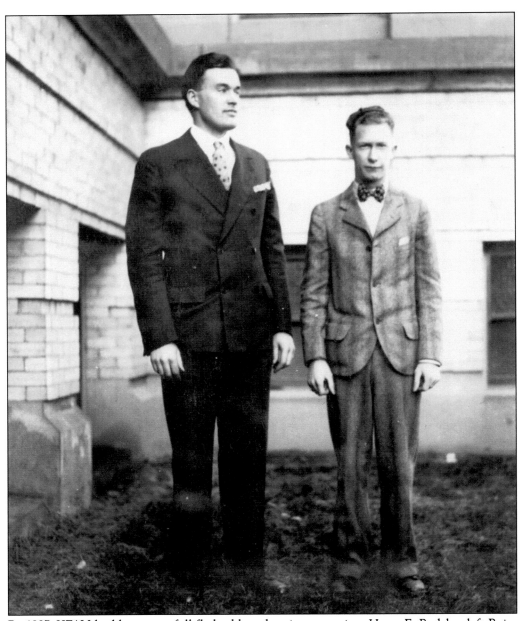

By 1927, KFAU had become a full-fledged broadcasting operation. Harry E. Redeker left Boise to take a job with the Federal Telegraph Company of Palo Alto, California, and later earned his doctorate in chemistry at Stanford University. Redeker taught chemistry at several colleges and then at the US Naval Academy before retiring in 1957. He then took a research position at Stanford University as a radiation chemist, retiring again in 1961. His position as director of KFAU was assumed by Harold G. Austin, who was assisted by Henry H. Fletcher, who went on to own and operate KSEI in Pocatello. Henry Fletcher was also one of Idaho's pioneer broadcasters, and ironically sold his radio station to Western Broadcasting Company of Missoula, Montana, the same company that would buy KIDO in 1976. Here, Harold Austin (left) and Henry Fletcher pose for a photograph at Boise High School. (Courtesy of the Idaho State Historical Society.)

Two
KIDO's Early Days

By 1928, KFAU had become too expensive for the Boise School District to operate and was put up for sale. Local businessmen offered to buy the station, but they only wanted to run it during daylight hours and at reduced power, which was unacceptable to the school board. So in August, they decided to take bids, and narrowed it down to two applicants. They selected the owners of KORE in Eugene, Oregon, over KEX in Portland. One of the owners of KORE was Curtis G. Phillips. He was born on December 29, 1897, in Portland and graduated from the University of Oregon in Eugene in 1923. In 1926, he and fellow college student Frank L. Hill, who he served with in France during World War I, bought radio station KGEH in Eugene, changing the call letters to KORE, to stand for Oregon. After purchasing KFAU in Boise, Phillips and his wife, Georgia, agreed to move to Boise and operate the station as part of the sales agreement. (Courtesy of Vern Moore, Lorraine Moore, and Jessica Shedd.)

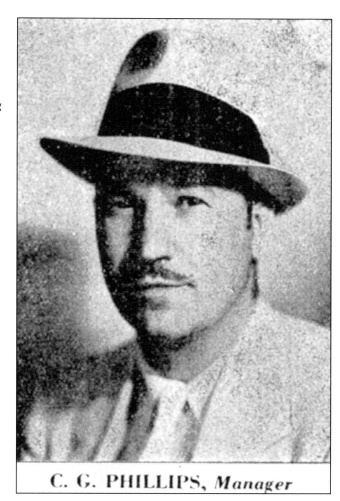

C. G. PHILLIPS, *Manager*

Harold G. Austin, Director
Henry H. Fletcher, Assistant

Power: 2000-4000 Watts
285.5 Meters
1050 Kc.

KFAU
"The Voice of Idaho"
Boise

October 18, 1928.

Mr. Harold A. Lafount,
Radio Commissioner,
Washington, D. C.

Dear Sir:

I am in receipt of your letter of October 10th, requesting further information as to broadcasting station KFAU, Boise, Idaho.

The Transmitter will be located on the top floor of the Boise Elk's Lodge. This building is on the outer edge of the business district of Boise. Buildings are not located on either the East, West or North side of this building. The residential district extends for three miles in all directions from this location.

We are sending you this date our contract with the Boise School District. They were very well pleased with our proposition and made a thorough investigation of our station at Eugene, Oregon before accepting our offer.

Mr. J. B. Newport, President of the Black Canyon Irrigation District of Idaho, is behind us in this enterprise and I am sure his standing will be found of the very highest. Mr. Newport, by the way, happens to be the writers father-in-law.

Mr. Hill and myself have made every effort to cooperate with you and the radio commission and certainly appreciate your very fine letters in respect to our operation of KORE; and we thoroughly believe that we will create the same friendly sentiment toward KFAU.

Boise has no daylight reception at present, and I am sure that this in itself will create a big interest in the local station.

Trusting this information meets your requirements, I beg to remain,

Respectfully yours,

BOISE BROADCAST STATION

C. G. Phillips. by
CBW.

Harold A. Lafount, the federal radio commissioner in Washington, DC, wrote C.G. Phillips requesting more information about the sale of KFAU. On October 18, 1928, Phillips wrote him back confirming that the transmitter would be on the top floor of the Elks Lodge at Ninth and Jefferson Streets. That was then considered the outer edge of Boise's business district, with Boise's residential area extending three miles in all directions. (Courtesy of Broadcast License Files Repository, National Archives, College Park, Maryland.)

The sale of KFAU took place on September 1, 1928. The Federal Radio Commission had just issued General Order 40, forcing KFAU to reduce power to 1,000 watts, change frequencies to 1,250 kilocycles, and share its nighttime hours with KXL in Portland, effective November 11. However, it appears they were allowed to sign on one day prior to Election Day, making KIDO's actual birth date Monday, November 5, 1928. (Courtesy of Broadcast License Files Repository, National Archives, College Park, Maryland.)

"KNOW YOUR ORDER BETTER"

P. G. FLACK — EXALTED RULER
E. W. JOHNSON — SECRETARY
ROBT. W. NEWTON — TREASURER

BOISE LODGE No. 310
B. P. O. ELKS

LODGE MEETINGS
WEDNESDAYS OF EACH WEEK

VISITING BROTHERS ALWAYS WELCOME

BOISE, IDAHO,
Nov. 22, 1928

Mr. Harold A. Lafount,
Radio Commissioner,
Washington, D. C.

Dear Sir:

First I wish to thank you for your immediate cooperation in helping to get KIDO (KFAU) on the air. We realize fully that your time is very well taken up, particularly during this time of re-allocation.

We are now situated in the Elks Temple, have a beautiful studio and full cooperation of this organization. The Boise business men and the community as a whole are very well pleased with the programs as conducted by this station.

We are giving listeners of this vicinity daylight reception -- something they have never enjoyed before. However, we are not trying to compete with the National Broadcasting Company programs so are getting off the air at not later than 8:00 o'clock, except on days of special features.

The night before election we hooked up with the National Broadcasting Company, and I can assure you everyone was certainly well pleased. It is hoped that some day we may be fortunate enough to be hooked up with that great chain, and any suggestions you may care to give us in regard to this matter will be deeply appreciated.

Mr. Jacobson, who is the Agricultural Statistician of Idaho, is very well pleased with the handling of KIDO, and he stated that he recently met you at Washington D. C.

As stated above, Mr. Hill and myself are very appreciative to you for your fine cooperation in the handling of matters pertaining to our new venture KIDO, as well as in connection with station KORE at Eugene, and anything we may be able to do to cooperate with you and the Radio Commission will afford us much pleasure.

Sincerely yours,

BOISE BROADCASTING STATION
Elks Temple, Boise, Idaho.

KIDO's first actual license (pictured) was issued on November 9, 1928, to Frank L. Hill and C.G. Phillips, doing business as Boise Broadcast Station. Back in the early days of radio, station licenses were only issued for three-month intervals, thus requiring those operating a broadcasting station to file a lot of government paperwork. (Courtesy of Broadcast License Files Repository, National Archives, College Park, Maryland.)

In 1934, with help from Sen. William E. Borah (pictured), KIDO got permission to increase its daytime power to 2,500 watts. KIDO had a good relationship with Senator Borah and broadcast many of his speeches as well as his funeral service on January 25, 1940, after the senator passed away at the age of 74 earlier that month. (Courtesy of Kris McEntee on behalf of Georgia M. Davidson.)

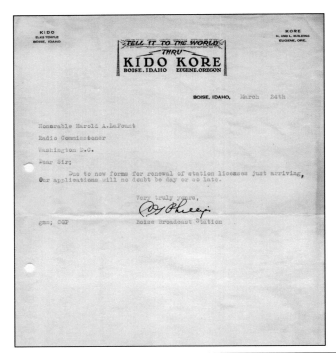

This letter appears to have been written on March 24, 1929, and advises commissioner Harold LaFount that KIDO's license renewal forms had just arrived and would result in a filing delay. Note the new logo at the top of the letterhead advising advertisers to "tell it to the world" on KIDO and KORE. In addition, KIDO's new location at the Elks Temple was now printed at the top left of the page. (Courtesy of Broadcast License Files Repository, National Archives, College Park, Maryland.)

KIDO needed to move its transmission tower from the roof of the Elks Temple to the Whitney Bench to improve its coverage and eliminate interference to nearby residents. Here, C.G. Phillips asks for and is granted a 30-day program test period. Note the many promotional phrases on this letterhead from September 1930, including a mention of the *Jack and Jill Club*, a new children's show hosted by Billy Phillips. (Courtesy of Broadcast License Files Repository, National Archives, College Park, Maryland.)

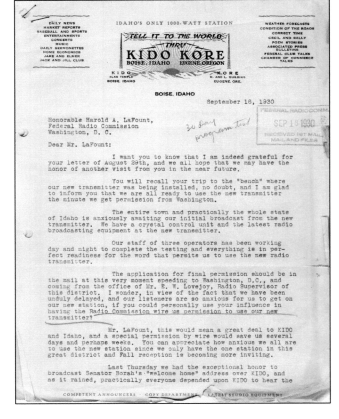

KIDO's twin towers were located behind the Phillipses' new home at 1010 Owyhee Street on the Whitney Bench. They were made of wood, painted international orange and white, and marked with "aviation red" warning lights. The small transmitter building to the left was specially constructed to house the new KIDO transmitter. The two towers supported the T antenna, which was fed from a wire coming from the transmitter building. (Courtesy of Broadcast License Files Repository, National Archives, College Park, Maryland.)

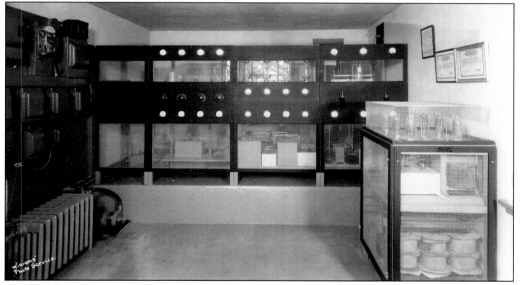

The building that housed KIDO's transmitter still exists. The Phillips house at 1010 Owyhee is now owned by Jenny Sternling, the daughter of Vera Sternling, who was married to KIDO engineer Don Cederstrom. The concrete pedestal at the rear, which the transmitter sat on, is also still there. It was in this building that Vern Moore began his career at KIDO as a transmitter engineer in the fall of 1935. (Courtesy of Kevin Godwin and Cindee Scholfield of Peak Broadcasting.)

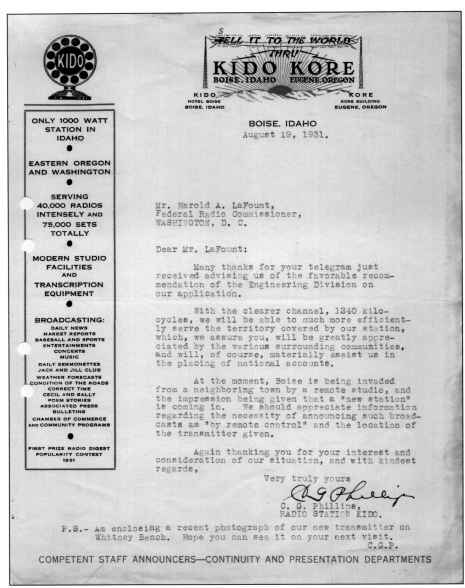

TELL IT TO THE WORLD
THRU
KIDO KORE
BOISE, IDAHO EUGENE, OREGON

KIDO
HOTEL BOISE
BOISE, IDAHO

KORE
KORE BUILDING
EUGENE, OREGON

BOISE, IDAHO
August 19, 1931.

Mr. Harold A. LaFount,
Federal Radio Commissioner,
WASHINGTON, D. C.

Dear Mr. LaFount:

Many thanks for your telegram just received advising us of the favorable recommendation of the Engineering Division on our application.

With the clearer channel, 1240 kilocycles, we will be able to much more efficiently serve the territory covered by our station, which, we assure you, will be greatly appreciated by the various surrounding communities, and will, of course, materially assist us in the placing of national accounts.

At the moment, Boise is being invaded from a neighboring town by a remote studio, and the impression being given that a "new station" is coming in. We should appreciate information regarding the necessity of announcing such broadcasts as "by remote control" and the location of the transmitter given.

Again thanking you for your interest and consideration of our situation, and with kindest regards,

Very truly yours

C. G. Phillips,
RADIO STATION KIDO.

P.S.- Am enclosing a recent photograph of our new transmitter on Whitney Bench. Hope you can see it on your next visit.
C.G.P.

COMPETENT STAFF ANNOUNCERS—CONTINUITY AND PRESENTATION DEPARTMENTS

In late 1930, KIDO's studios were moved to the basement of the newly constructed Hotel Boise, which officially opened in December of that year. Vern Moore said KIDO's "commodious" studios were situated right next to the men's restroom, and if you listened closely, you could hear when the toilets were flushed. There was a control room with record storage and a "studio Steinway" piano. They used double-button carbon microphones, small turntables that played 78s, and two large floor-mounted transcription turntables that were used to play radio shows and soap operas like *Ma Perkins*, which were distributed on 16-inch discs. This letter, dated August 19, 1931, shows the newly updated KIDO letterhead from 1931 saying "sell it to the world" and listing KIDO's latest audience and program information. In the letter, Curt Phillips also complains to commissioner LaFount about KFXD, a new Nampa station that had just opened a remote studio in Boise at the Owyhee Hotel. (Courtesy of Broadcast License Files Repository, National Archives, College Park, Maryland.)

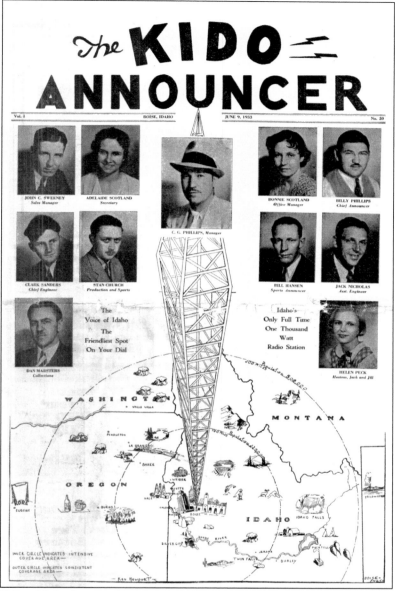

In 1933, KIDO published a newspaper known as the *KIDO Announcer*. This is the 20th and final issue from June 9, 1933. It celebrated the erection of KIDO's new vertical transmission tower, which was soon to replace the twin towers after they had been damaged in a windstorm earlier that spring. KIDO touted itself as "Idaho's Only Full Time One-Thousand Watt Radio Station." The cover shows massive signal coverage into six states with "intensive" 100-mile coverage in the inner circle, and "consistent" 200-mile coverage in the outer circle. The population figures were also impressive for 1933. However, it is indeed possible that with 1,000 watts and so few other stations on the air at that time, KIDO's nighttime coverage could very well have gone that far, and its daytime reach could have been expanded too. The station received regular reception reports from all over the west, and if conditions were right, sometimes from foreign countries. (Courtesy of Vern Moore, Lorraine Moore, and Jessica Shedd.)

The Communications Act of 1934 created the Federal Communications Commission. But prior to that, the Radio Division of the US Department of Commerce conducted regular inspections of radio stations. One of the inspectors who regularly came to Boise was O.R. Redfern. The unidentified inspector in this photograph appears to be rather serious, as though he means business. The vehicle was impressive, with a running board and covered spare tire. (Courtesy of Kevin Godwin and Cindee Scholfield of Peak Broadcasting.)

C.G. "Kiddo" Phillips had his own newspaper column in the *KIDO Announcer.* In his June 9, 1933, feature, Phillips thanked everyone for their "splendid" support, and mentioned giving free time to the Boise Ministerial Association for a daily on-air devotional. He also cited KIDO's broadcast of the recent music week program and its coverage of several distinguished speakers like Gov. C. Ben Ross. He ended his column with "Cheerio, Everyone, Kiddo." (Courtesy of Vern Moore, Lorraine Moore, and Jessica Shedd.)

Adelaide Scotland was KIDO's secretary in 1933. In this edition of the *KIDO Announcer*, there was a column called the "Pavement Pounder" that was reporting, for one last time, "what he saw" during the first week of June 1933. Among those mentioned in the column was KIDO secretary Adelaide Scotland "pouting prettily" about her picture on the front page. Apparently, this 1933 photograph of her did not please her. (Courtesy of Vern Moore, Lorraine Moore, and Jessica Shedd.)

ADELAIDE SCOTLAND
Secretary

BONNIE SCOTLAND
Office Manager

Bonnie Scotland was KIDO's office manager in 1933 and remained with the station for many years. She was also the personal secretary of owner and manager "Kiddo" Phillips. In later years, Katherine "Kate" Scotland was KIDO's music librarian. (Courtesy of Vern Moore, Lorraine Moore, and Jessica Shedd.)

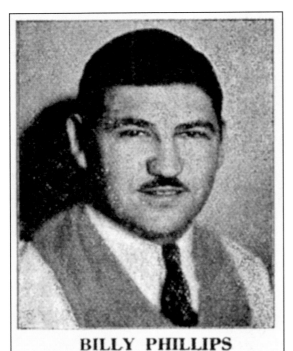

BILLY PHILLIPS
Chief Announcer

Billy Phillips was the brother of "Kiddo" Phillips and host of the *Jack and Jill Club*. Vern Moore said that youngsters would gather outside of the studios to hear "Barnacle Bill" and "Happy Birthday," which were then dedicated to other children. Kids and parents wanting to perform also showed up and it was a "madhouse," with the staff trying to assist "Uncle Billy" in maintaining "some semblance of control." (Courtesy of Vern Moore, Lorraine Moore, and Jessica Shedd.)

HELEN PECK
Hostess, Jack and Jill

Helen Peck was the lovely co-hostess on the *Jack and Jill Club*, which, according to "Kiddo" Phillips, had over 10,000 children as members, with its ranks growing all the time. Children could join the club simply by sending a letter to KIDO, giving their birthday and a promise to "mind their mother and father." Parents must have loved it. (Courtesy of Vern Moore, Lorraine Moore, and Jessica Shedd.)

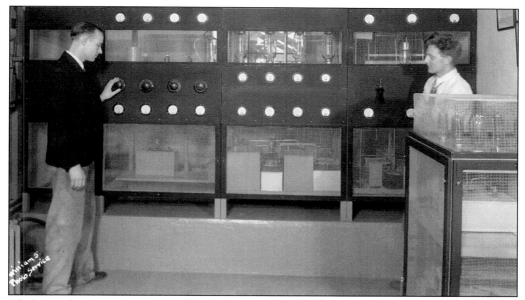

Clark Sanders (right) was KIDO's chief engineer in 1933 and was kept busy with all of the technical changes the station was going though at the time. Jack Nicholas (left) was Sanders's assistant engineer and helped with the installation of KIDO's new vertical tower. They are seen here adjusting KIDO's 1,000-watt transmitter, which was on the Whitney Bench. (Courtesy of Kris McEntee on behalf of Georgia M. Davidson.)

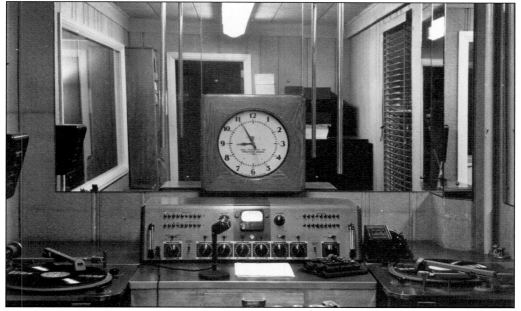

KIDO was always making improvements to its studio equipment. According to longtime KIDO announcer Vern Moore, the two large, floor-mounted transcription turntables in the Hotel Boise basement control room probably came from a theatre and were originally used to play the soundtracks of the early talking pictures, or "talkies." Each had two pickup arms: a vertical one and a lateral one. (Courtesy of Kris McEntee on behalf of Georgia M. Davidson.)

STAN CHURCH
Production and Sports

Stan Church did production and sports for KIDO. According to "Kiddo" Phillips, "all athletic contests, including primarily football and fights, were broadcast directly from the scene of action." KIDO's production facilities included the latest in transcription equipment, and an ever-increasing record library, some of which was donated to the station by the public. (Courtesy of Vern Moore, Lorraine Moore, and Jessica Shedd.)

BILL HANSEN
Sports Announcer

Bill Hansen was one of the announcers mentioned by Vern Moore as being an important part of KIDO's sports coverage over the years. Sponsors were of course needed too, and "Kiddo" Phillips was very appreciative of Edward L. Sproat of the Gem State Oil Company for his company's sponsorship of "all Boise High School sports." (Courtesy of Vern Moore, Lorraine Moore, and Jessica Shedd.)

John C. Sweeney was KIDO's sales manager. In 1933, the station had many local and national accounts. Some KIDO sponsors included the Mode Tea Room, the Rialto Theatre, Compton's Transfer, the Dewey Palace Hotel in Nampa, Caldwell Flour Mills, and Holy Rosary Hospital in Ontario. (Courtesy of Vern Moore, Lorraine Moore, and Jessica Shedd.)

JOHN C. SWEENEY
Sales Manager

DAN MARSTERS
Collections

Dan Marsters was KIDO's collections manager. Even during the Depression, businesses had to sell their goods and services, and KIDO helped them do so and stay in business during the tough economic times. KIDO sometimes took merchandise as a write-off for advertising accounts that could not pay their bill. Vern Moore recalls getting food credits, in lieu of payment, from two restaurants: the Mechanafe and the Idanha Cafe. (Courtesy of Vern Moore, Lorraine Moore, and Jessica Shedd.)

The Home of KIDO

We salute your progressive vision ---
May your new tower send the
ever more resonant Voice of
Idaho to the listening world

Hotel Boise

COMMUNITY-OWNED AIR-COOLED

A "community hotel" was the dream of Boise businessman W.E. Pierce, who convinced 530 Idaho stockholders to put up over $450,000 at the start of the Great Depression. Two years after it was built, the hotel had liabilities of $538,000. However, four years later, it had paid down $200,000 of its debt and had a 96-percent occupancy rate. KIDO was an important Hotel Boise tenant right from the beginning. (Courtesy of Vern Moore, Lorraine Moore, and Jessica Shedd.)

KIDO called itself "Idaho's Voice," which is reflected in this advertisement for Radio Supply Company, located at 1017 Main Street. In 1933, paying $59.50 for a car radio was expensive. However, that was the price "installed in your car" and undoubtedly helped increase the resale value and appeal of a vehicle, not to mention the enjoyment it brought to those listening. (Courtesy of Vern Moore, Lorraine Moore, and Jessica Shedd.)

Idaho's Voice

Is greater than ever

We, as radio dealers, can readily appreciate this new service that KIDO brings Intermountain Radio listeners.

You Can Enjoy

KIDO

And the rest of the Country's Broadcasting Stations with a

PHILCO

Transitone

$39.95 --- $59.50

Installed in Your Car

Radio Supply Company

Wholesale - Retail

1017 MAIN PHONE 1020

Theodore H. Wegner was president of the Boise Chamber of Commerce and viewed KIDO as a means of gaining publicity for the city of Boise. KIDO was part of a group of radio stations that exchanged programs about each other's city as a way of educating others about different parts of the country. Undoubtedly, KORE also participated in this exchange program. (Courtesy of Vern Moore, Lorraine Moore, and Jessica Shedd.)

Boise Chamber of Commerce

Mr. C. G. Phillips, Manager
Radio Station KIDO,
Boise, Idaho.

Dear Mr. Phillips:

The Boise Chamber of Commerce takes this opportunity to extend its heartiest congratulations to the management of KIDO on the occasion of the dedication of your new transmitting tower, which should materially benefit the radio listeners within the range of your station, as well as increase your broadcast range and bring many thousands of listeners within the scope of KIDO.

Improvement in your service will undoubtedly mean considerable in the publicity way of the City of Boise, and the Boise Chamber of Commerce is truly appreciative of the enterprise exhibited by your station in installing, at considerable expense, these new facilities.

We desire also at this time to thank you for your fine cooperation in sponsoring the series of exchange programs throughout the intermountain region and the coast cities. We believe that this service, which has been rendered to the chamber of commerce at no cost by the management of KIDO, will be materially beneficial in bringing a great amount of publicity in the recreational way to Boise and to Idaho.

Again, congratulations, and best wishes for your future success.

Yours very truly,
BOISE CHAMBER OF COMMERCE,
Theo. H. Wegener, President

Tune in on
Golden Rule Dinner Hour
Every Evening
6 to 7

ON THE AIR
SINCE THE FIRST
INITIAL BROADCAST
NOVEMBER 5, 1928

The Golden Rule Store had been sponsoring *Dinner Music* from 6:00 p.m. to 7:00 p.m. every night on KIDO since its very first night on the air, November 5, 1928. Dinner music was soft instrumental music, and it was quite common for radio stations to feature this type of programming at that hour. KBOI in Boise was still running *Starlight Serenade* as late as 1972. (Courtesy of Vern Moore, Lorraine Moore, and Jessica Shedd.)

Congratulations
KIDO

The construction of your new transmitting tower is truly a forward step in the broadcasting field. Your "Abreast of the Times" spirit is deserving of very high praise and not only assures your success, but the success of all whose programs are transmitted from such splendid equipment.

Gem State
Oil Co.

| Vico | Atlas | Pep 88 |
| Motor Oil | Tires | Gasoline |

In this print advertisement, Gem State Oil Company pointed out that not only was KIDO's new vertical antenna a positive improvement for the station and its listeners, but that advertisers would benefit too. Who knows if more Pep 88 gasoline was sold as a result of the new antenna, but having more listeners able to hear your radio program certainly did not hurt sales. (Courtesy of Vern Moore, Lorraine Moore, and Jessica Shedd.)

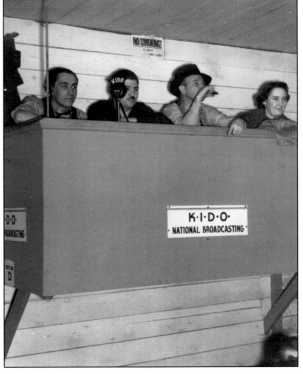

"Kiddo" Phillips liked to attend sporting events almost as much as he liked smoking cigars. This small press box was probably at Public School Field, where Phillips was ignoring the "No Smoking" sign. Seen from left to right are engineer Harold Toedtemeier, announcer Billy Phillips, "Kiddo" Phillips, and music librarian Katherine Scotland. (Courtesy of Kris McEntee on behalf of Georgia M. Davidson.)

FRC 660

UNITED STATES OF AMERICA
FEDERAL RADIO COMMISSION
WASHINGTON

NOT TRANSFERABLE
M

AMATEUR RADIO STATION LICENSE

This license is valid until 3 o'clock a.m., eastern standard time, 3 years from date of issuance, subject to the provisions of all treaties, laws, orders, and regulations that apply to amateur radio stations.

Licensee and fixed station location:

Vern Eldon Moore,
4103 S.E. Main Street,
Portland, Oregon.

Call letters:

W 7 E D P

Date of issuance:

6-29-34

This license vests no right to operate the station nor to the use of authorized frequencies beyond the term hereof, nor in any other manner than authorized herein. This license is subject to the right of use or control by the Government of the United States under section 6 of the Radio Act of 1927.

FEDERAL RADIO COMMISSION
Herbert L. Pettey, Secretary

Vern Eldon Moore was 18 years old when he received his amateur radio license. Growing up in Portland, he attended Benson Polytechnic High, which owned KBPS, a student radio station that shared time with KXL. Moore enrolled at the Oregon Institute of Technology, got his FCC license, and was hired by William Allingham to run KBPS. When "Kiddo" and Georgia Phillips heard him on the air, they hired him instantly. (Courtesy of Vern Moore, Lorraine Moore, and Jessica Shedd.)

At age 19, Moore traveled to Boise from Portland in the backseat of "Kiddo" Phillips's Packard. He roomed at Case House, at Thirteenth and Bannock Streets, and rode his bicycle across the Eighth Street Bridge and up Depot Hill for his shift at the transmitter site, which he enjoyed because he got to play with the Phillips girls, Bette and Sherli, who helped pass the time. (Courtesy of Vern Moore.)

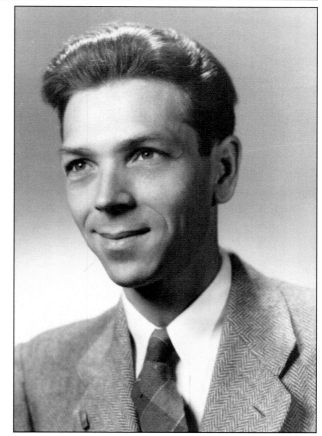

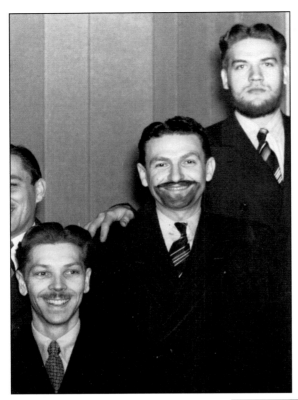

In addition to Vern Moore, KIDO acquired some top-shelf talent on both the announcing and the technical side. Seen here, from left to right, are Harold Toedtemeier (partially seen on the far left), the chief engineer; and announcers Vern Moore; Art Letourneau, sporting what appears to be a painted-on goatee; and Clete Lee, whose real name was Cletus Schwitters. (Courtesy of Vern Moore.)

KIDO's new 229-foot vertical antenna, located near the intersection of State Street and Collister Drive, was placed in service on October 20, 1936. A building was constructed on Wiley Lane next to the Boise River. Flooding was an issue, and a rowboat was always handy, with instructions on which pieces of gear to take in case the transmitter operator had to make a quick escape. (Courtesy of Kris McEntee on behalf of Georgia M. Davidson.)

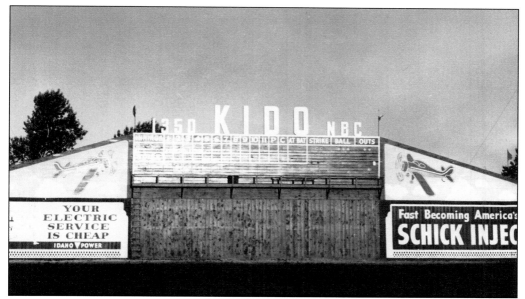

KIDO covered the home games of the Boise Pilots baseball team, who played at Airway Park. This new scoreboard was constructed by KIDO to advertise its call letters and dial position. Note the two main sponsors and their respective ads. Idaho Power was touting that "your electric service is cheap" and Schick Razors was talking up its latest "injector" blade. (Courtesy of Vern Moore.)

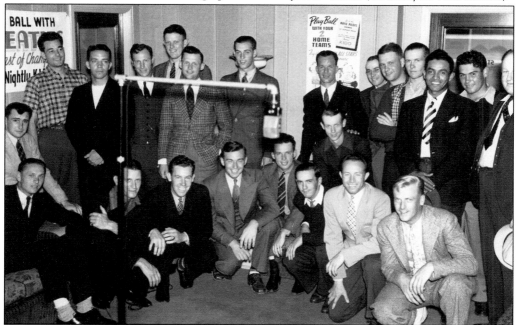

Wheaties sponsored KIDO's Boise Pilots broadcasts. For away games, Western Union sent play-by-play reports. Announcer Roy Civille would then re-create the game using his fingernail on a pencil to simulate the crack of the bat. The control room mixed in music and recorded sound effects where appropriate. Civille's re-creations made you believe you were actually there. He is seen here in the top left wearing a checkered shirt. (Courtesy of Vern Moore.)

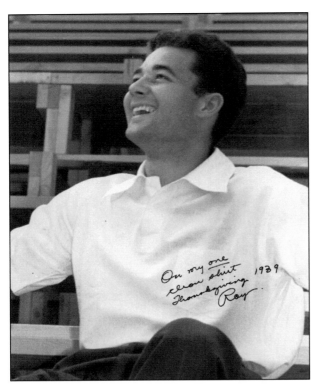

Roy Civille also wrote a weekly column for KIDO in the late 1930s called the "KIDO Dial-Log," which was a weekly preview of upcoming programs on KIDO. The station got plenty of ink in the *Idaho Statesman* and wrote a second popular column called "Thru the Kiddo Key-Hole," which was written by a fictitious writer named Ben Peekin, helping the reader complete the phrase, "Been peeking through the Kiddo key-hole." (Courtesy of Vern Moore.)

This Christmas card was sent out to KIDO advertisers and associates in the late 1930s. Owner Curtis "Kiddo" Phillips appears to be directing the singers—the KIDO staff. (Courtesy of Vern Moore, Lorraine Moore, and Jessica Shedd.)

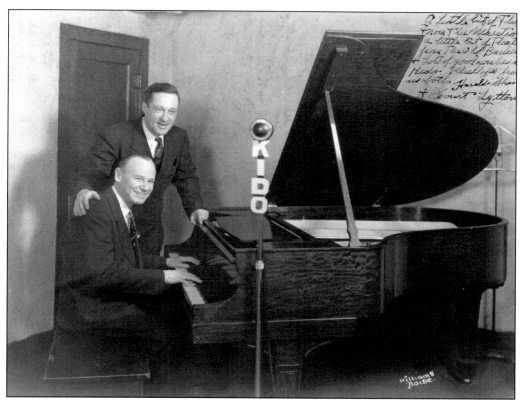

According to Vern Moore, Court Lytton was the "man of many voices." Here, musician Harold Shaw (seated) and Lytton offer "a little bit of this-a from the Maestro, and a little bit of that-a from the old barber, and lots of good wishes to Kido Phillips from the both of us." (Courtesy of Kris McEntee on behalf of Georgia M. Davidson.)

The kitten on this postcard was a radio celebrity named Kido. He was reportedly rescued from the street "on a dark and dismal winter night." The photograph on the right of this card shows off the white grand piano in KIDO's new studios on the mezzanine of Hotel Boise. (Courtesy of Frank Aden Jr.)

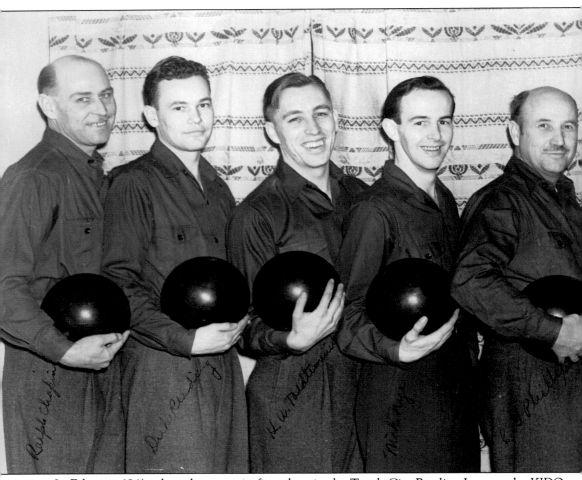

In February 1941, when they were in first place in the Tough City Bowling League, the KIDO bowling team posed for this team photograph. From left to right, they are Ralph Chapin, Duke Reading, Harold W. Toedtemeier, Nick Nye, and "Kiddo" Phillips. Phillips had been quite an athlete in his earlier days; as a member of the University of Oregon basketball team, he was known as "Shrimp Phillips." (Courtesy of Vern Moore.)

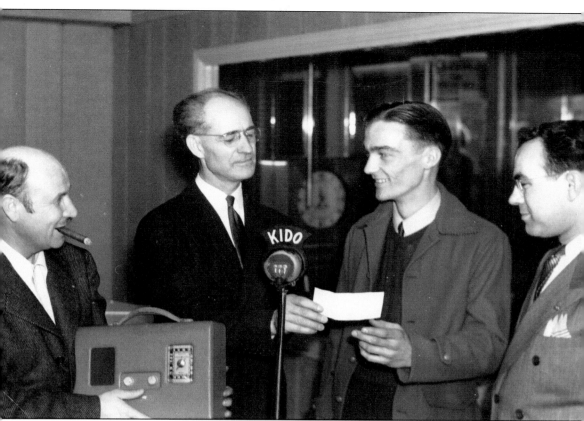

KIDO owner Curtis G. "Kiddo" Phillips (left) and announcer Hal Stewart (far right) present a portable radio and a check to a contest winner. Phillips passed away of a heart attack on June 20, 1942. News reports said he had been in good health and was found unconscious by his wife after rising in the morning, and died soon after. Phillips loved to smoke cigars and there are many "Kiddo" Phillips cigar stories told by former KIDO employees. After cleaning out a convertible he purchased from Phillips, engineer Jim Johntz found hundreds of paper cigar bands left in the car. Transmitter operator R.W. Egelston remembers the time Phillips dove off the diving board into the swimming pool of the Boise YMCA while still holding his cigar. Vern Moore described him as being at the microphone during local sports broadcasts "cigar in hand." That was the "Kiddo" Phillips everyone knew and loved. (Courtesy of Vern Moore.)

KIDO became Idaho's first network station by affiliating with NBC on October 1, 1937. This paved the way for KIDO-TV to become an NBC television affiliate in 1953. Boise was one of the only markets of its size not to have live network service, so the move to NBC was long overdue. It took a record-breaking 776 miles of high-fidelity telephone lines coming from Ogden, Utah, to bring NBC to Boise. KIDO was charged for the construction cost against its network compensation payments, and it took eight long months to pay it off. Vern Moore remembers the first check from NBC was for $28.70. KIDO promoted the arrival of NBC with progress bulletins as the construction of the phone lines neared completion. On September 15, they had less than 40 miles to go. On September 21, KIDO received a telegram informing them that the lines were complete and that network service would begin on October 1. This is the front of the two color brochures NBC printed to sell advertisers on the significance of KIDO's affiliation. (Courtesy of Vern Moore.)

Three
LIVE FROM NEW YORK, IT'S NBC

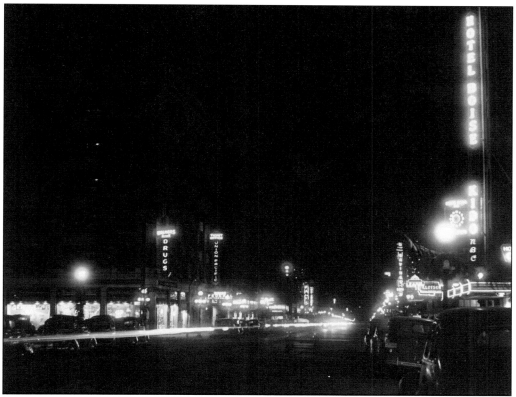

KIDO had done the impossible—brought live network service to Boise. The station was of course proud of this feat and immediately incorporated NBC into everything it did. In fact, for years, the words "KIDO NBC in Boise" were used on the air. This nighttime photograph shows the neon sign on the corner of the Hotel Boise building proudly proclaiming that KIDO was now an NBC affiliate. (Courtesy of Vern Moore.)

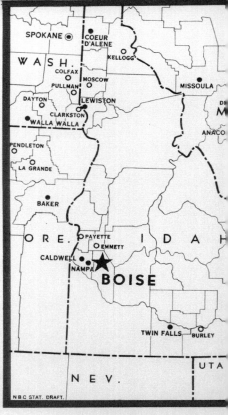

SERVES A VALUABLE MARKET

KIDO at Boise becomes a member of NBC's North Mountain Group—and the only station in Idaho associated with a national network.

NBC coverage of another rich, important territory becomes greatly strengthened. KIDO operates full time on a regional-channel frequency of 1350 kilocycles with Daytime power of 2500 watts and Nighttime power of 1000 watts. It is the only radio station in Boise.

The city of Boise with a population of 21,544 is the 7th largest retail market in the Mountain states. Its trading area has a population of 120,000. Per capita income in Boise is higher than that in any other city of the eight Mountain states except Denver, Salt Lake City and Reno.

Now under construction are several hundred miles of special wire-lines from Salt Lake City to carry the programs of the National Broadcasting Company from points throughout the United States and the world to KIDO's transmitter at Boise. When this construction has been completed—about October 1, 1937, it is expected—KIDO will actively become an NBC affiliated station.

Bringing the NBC Radio Red and Blue Networks to Boise allowed NBC to form the new North Mountain Group, consisting of three stations: KIDO in Boise; KGIR in Butte, Montana; and KGHL in Billings, Montana. NBC's color brochure underscored the significance of the event with the line "further improving NBC Network service" at the bottom of the page. Adding KIDO also allowed NBC to combine the populations of the 64 counties that made up the three markets,

KIDO BOISE

THE NEW
NORTH MOUNTAIN GROUP

With the addition of KIDO, the North Mountain Group consists of three stations.

		Frequency	Power-Watts
KGHL	Billings, Montana	780 kc	1000—(5000D)
KGIR	Butte, Montana	1340 kc	1000—(2500D)
KIDO	Boise, Idaho	1350 kc	1000—(2500D)

The market served by this group is great and prosperous. It embraces 64 counties with 625,900 population and 158,960 families—of which 109,550 are radio families. It includes practically all of Montana and Idaho, as well as portions of Nevada, Oregon and Wyoming. Its spendable income is $267,267,000, and its retail sales are $131,940,000.

This valuable market is completely blanketed by the North Mountain Group's three stations. These stations are well established and highly popular, and have a large, exceedingly loyal audience. The families they serve—the radio listeners in this great territory of the North Mountain states—are even more dependent upon radio for news and entertainment than families in many other territories.

The North Mountain Group—and its fine, thorough coverage—is available to advertisers for use with either the Blue or Red Network.

as well as that of western Wyoming, to reach 625,900 people, which to radio time-buyers on the east coast began to look like something worth reaching. In fact, NBC started out the sales piece by saying KIDO "serves a valuable market." Time buyers agreed and national revenues flourished for both KIDO and NBC. (Courtesy of Vern Moore.)

KIDO — NBC

DEDICATION
DINNER AND DANCE
FRIDAY, OCTOBER 1, 1937, 7:30 P. M.
HOTEL BOISE—CRYSTAL BALLROOM

NO. **21** PLATE $1.00

A total of 200 invited guests attended the special $1-a-plate NBC dedication dinner and dance on October 1, 1937, at the Crystal Ballroom in Hotel Boise. Gov. Barzilla Clark, his wife, Ethel, and Boise mayor J.L. Edlefsen gave congratulatory speeches, with "Kiddo" Phillips delivering the response. Music was supplied by Jim Baker and his orchestra. (Courtesy of Vern Moore.)

The *Jack and Jill Club*'s newsletter was called the *Monthly Moo*. It too celebrated KIDO's historic feat of bringing the NBC radio network to Idaho, proclaiming, "We didder—roped and tied that maverick NBC." The poem at the bottom of the page compared KIDO to inventor Robert Fulton's steamboat, saying they were both successful because they "stuck to it." (Courtesy of Vern Moore.)

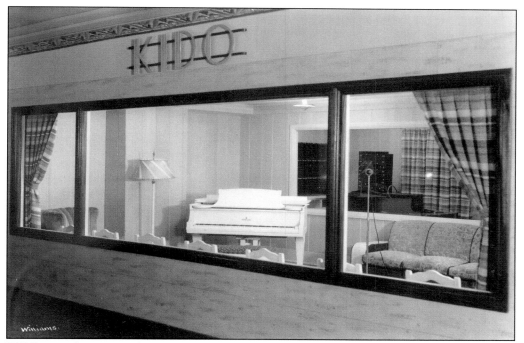

KIDO moved to new studios on the mezzanine of the Hotel Boise on June 15, 1937. According to the *Boise Capital News*, the studio had five rooms: two for business offices, two for broadcasting purposes, and a waiting room. Large windows allowed the public to watch live broadcasts while a speaker played the off-air sound to them live as it happened. (Courtesy of Kris McEntee on behalf of Georgia M. Davidson.)

The *Boise Capital News* went on to say that the interior of the studio featured "indirect lighting, attractive furniture and almost perfect acoustics," making it one of most modern in the United States. The article also said that former child actor Jackie Coogan, after seeing KIDO's new studio, remarked, "Boy, I'd like to stay here for the night." (Courtesy of Kris McEntee on behalf of Georgia M. Davidson.)

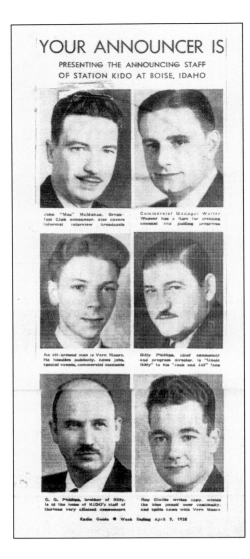

YOUR ANNOUNCER IS

PRESENTING THE ANNOUNCING STAFF
OF STATION KIDO AT BOISE, IDAHO

This *Idaho Statesman* advertisement from 1938 identified six of the announcers regularly heard on KIDO. They are, from left to right starting at the top, Breakfast Club host John "Mac" McMahon, commercial manager Walter Weaver, all-around-man Vern Moore, chief announcer and program director Billy Phillips, station owner Curtis "Kiddo" Phillips, and news announcer and re-creator of baseball games, Roy Civille. (Courtesy of the Idaho State Historical Society.)

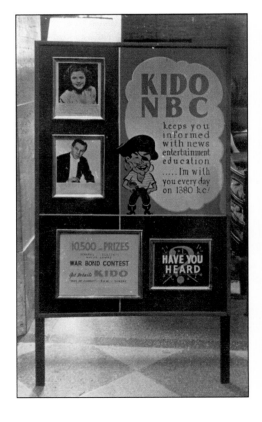

The pirate character Captain Kid-O was used in KIDO promotional advertisements starting in the late 1930s. This Hotel Boise lobby display from the early-to-mid-1940s promotes $10,500 in prizes from a General Electric war bond contest on the *Hour of Charm* program, which aired at 8:00 p.m. on Sunday nights on KIDO over the NBC Radio Network. (Courtesy of Jimmy and Andy Johntz.)

The move to NBC gave KIDO the opportunity to feed stories to the network for national coverage. Both Pres. Franklin D. Roosevelt and his wife, Eleanor Roosevelt, visited Boise and were interviewed on KIDO for NBC. This late-1930s photograph shows other businesses located near the Hotel Boise, including Popma Music Company, W.E. Pierce Real Estate—the developers of Hotel Boise—and Standard Furniture. (Courtesy of Kris McEntee on behalf of Georgia M. Davidson.)

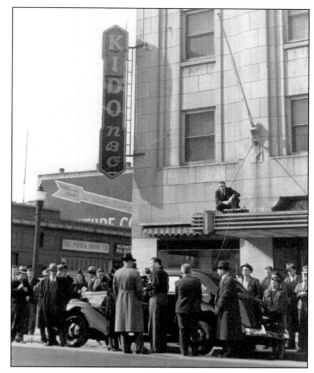

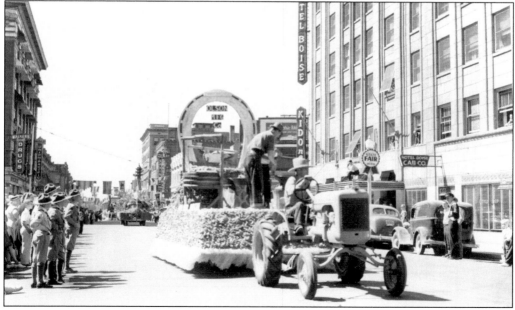

KIDO's move up to the mezzanine in Hotel Boise provided an excellent view of events taking place below at Eighth and Bannock Streets. Note the open windows on the second floor and what appears to be live coverage from the top of the roof above the main entrance on Eighth Street. The KIDO control room was on the corner of the building where the last three windows are unopened. (Courtesy of the Idaho State Historical Society.)

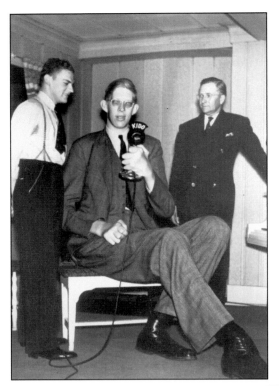

KIDO's Clete Lee interviewed Robert P. Wadlow, said to be the tallest man in the world, in the KIDO Hotel Boise studios in the late 1930s. Seen here, from left to right, are Lee, Wadlow, and Wadlow's manager, who rests his hand against the white grand piano in KIDO's main studio. (Courtesy of the Idaho State Historical Society.)

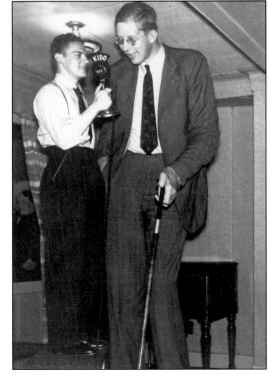

Wadlow was born on February 22, 1918, in Alton, Illinois. He had a rare disease that caused him to continue to grow and contributed to his death at the age of 22. When he died on July 15, 1940, he was 8 feet and 11 inches tall. KIDO announcer Clete Lee had to stand on a table to interview him, and Wadlow's head was touching the ceiling of the Hotel Boise studio. (Courtesy of the Idaho State Historical Society.)

ROY: Tonight, as a special feature of KIDO's 10th anniversary as a broadcasting station, and in honor of KIDO's first year of affiliation with the network of the National Broadcasting Company, we are going to review the career of station KIDO, right from its very beginning. In imagination, then, follow us back to the month of August, in the year 1928!

MUSIC: 1st theme....full 10 seconds...fade briefly....and out

VERN: The scene is the town of Parma, Idaho. Mr. C.G. Phillips, of Eugene, Oregon, is visiting Idaho on a vacation. He picks up a newspaper and begins to look it over.

SOUND: Newspaper rustling

CURT: Say -- look here! It says, "KFAU on the block!" Why, that's the high school station over in the state capital. What do you say we drive over there and look into this sale. It can't do any harm!

VERN: And so a few hours later, Mr. Phillips turned up in the city of Boise. After a furious time trying to locate all the members of the school board, the deal was finally closed......And here we get the first glimpse of the personality of the man who was to manage Idaho's greatest radio station: he sits down, takes a pen, and scratches off a brief note to his partner, Frank Hill, in Eugene.

SOUND: Scratching of pen on paper

CURT: (Slowly) Dear Frank........Believe it.....or....not.....we have just bought......another......radio station!

VERN: And a couple of days later, Mr. Hills telegraphed reply arrived.

SOUND: Morse code continuing while VERN reads

VERN: That's OK by me -- if YOU want to RUN it!

KIDO's 10th anniversary was celebrated with a special live program broadcast on November 5, 1938, called the *KIDO Cavalcade*. This is the actual script for the live program that aired that night, which featured announcers Roy Civille, Vern Moore, and owner "Kiddo" Phillips telling the story of how KIDO came to be and of the progress the station had made in the past 10 years. From the way the script reads, it appears that Phillips bought KFAU without telling his partner, Frank L. Hill, the co-owner of KORE in Eugene. While this story cannot be confirmed, it certainly did contribute to Phillips's reputation as an impulsive individual. At the bottom of the page, the story says that Hill was fine with Kiddo buying KFAU, as long as he wanted to run it. (Courtesy of Vern Moore, Lorraine Moore, and Jessica Shedd.)

On March 29, 1941, KIDO changed frequencies from 1,350 to 1,380 kilocycles, as mandated by the Federal Communications Commission. This second-edition international radio news map showed the world as it existed in August 1941 and gives a timeline of world events from 1935 until then. Inside the map, listeners were advised to "keep informed on the latest world developments via NBC and the KIDO-United Press News Bureau." (Courtesy of R.W. Egelston.)

First with the News!

KIDO

1380 kc.

KIDO listeners are kept in close touch with World developments through the NBC news room, regularly scheduled and special on-the-spot reports from all news centers via NBC's world-wide short-wave facilities and NBC's outstanding commentators.

In frequent, conveniently scheduled newscasts, the KIDO News Bureau offers fast complete coverage of World, national and local news through the facilities, of the special radio wire of United Press, with added local coverage by KIDO's own staff newsmen.

KIDO
News Schedule

7:45 a.m.	Monday through Saturday
10:00 a.m.	Monday through Saturday
11:45 a.m.	Monday through Friday
12:00 noon	Sunday
12:30 noon	Monday through Saturday
2:55 p.m.	Monday through Friday
4:25 p.m.	Saturday
4:30 p.m.	Sunday
5:15 p.m.	Monday through Friday
5:45 p.m.	Monday through Saturday
7:15 p.m.	Friday
7:30 p.m.	Monday, Wednesday, Saturday
7:45 p.m.	Saturday—H. V. Kaltenborn
8:00 p.m.	Tuesday
9:15 p.m.	Monday through Saturday
10:00 p.m.	Sunday—Walter Winchell
10:00 p.m.	Thursday—H. V. Kaltenborn
10:55 p.m.	Monday, Wednesday, Friday

By this time, KIDO had been an NBC network affiliate for over three years. But KIDO also offered local news throughout the day, from 7:45 a.m. to 10:55 p.m. Monday through Friday, as well as regular local newscasts on Saturday and Sunday relying on its United Press International radio wire service and its own local news staff. (Courtesy of R.W. Egelston.)

Georgia Marie Newport was born on May 18, 1907, in Notus, Idaho. As a senior at the University of Oregon, she was filling in for the piano player for a quartet singing on KORE radio when she met the station's co-owner, Curtis G. Phillips. They fell in love and married. While visiting Georgia's parents in Parma in 1928, they read about the auction of the Boise High School station KFAU in the newspaper. They submitted the winning bid for the station and moved to Boise to operate it. After Curtis "Kiddo" Phillips suddenly died in 1942, Georgia married R. Mowbray Davidson, the owner of Peasley Transfer and Storage, in 1946. She went on to build KIDO-FM, one of the first licensed FM stations in Idaho. She then filed Idaho's first application for a television station after the "freeze" on new applications was lifted in 1952. KIDO-TV signed on the air on July 12, 1953. She was a remarkable woman, and one of the true pioneers of Idaho broadcasting. She passed away on April 6, 1997, of natural causes at the age of 89. (Courtesy of Judi Albert.)

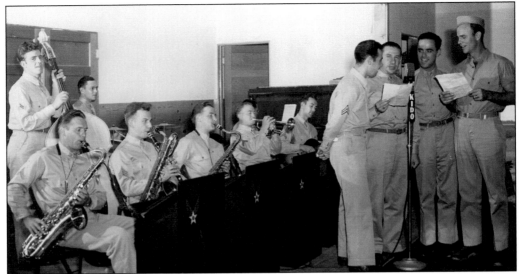

On December 7, 1941, the United States entered World War II after Pearl Harbor was attacked. According to Vern Moore, nearby Gowen Field became a major base, with servicemen from all over the country stationed there. One of the many ways the Army tried to boost morale was with music, played by the Gowen Field Army Band. This 1942 photograph shows a men's quartet singing on a live radio broadcast on KIDO. (Courtesy of Vern Moore.)

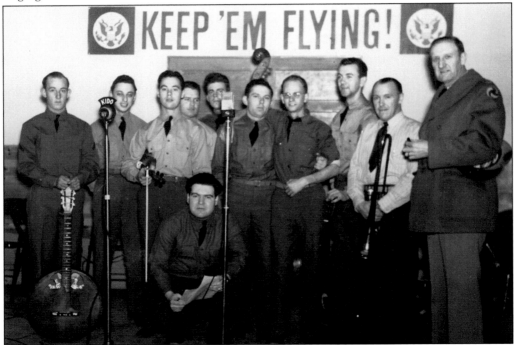

The 1943 Gowen Field Army Band boasted a string bass, a fiddle, a slide trombone, and a rather exotic-looking guitar. "Keep 'Em Flying!" was the motto of the day as World War II continued to command the nation's total attention. This particular band featured both young and old servicemen. (Courtesy of Vern Moore.)

Four

THE LATE 1940S AND EARLY 1950S

Charter Member

KIDO-FM'ers

THIS IS TO CERTIFY THAT ____Vern E. Moore____

residing at __812 Alturas__ ____Boise____ ____Idaho____

is a charter member of the **KIDO-FM'ers**

 This charter member is entitled to receive all privileges of KIDO-FM, including high fidelity, no fading, no static, no station interference radio reception, on

102.1 megacycles - channel 271

 This charter member is also entitled to receive special FM program notices and regular FM program schedules from KIDO-FM.

RADIO STATION KIDO-FM

DATE __January 25, 1947__ WALTER E. WAGSTAFF, *General Manager*

After the war, the Federal Communications Commission moved the FM band to its present parameters between 88.1 and 107.9 megacycles. KIDO applied for a frequency and was granted a construction permit for 3,000 watts on 102.1, which was channel 271. Vern Moore was a charter member of the KIDO FM'ers Club and received this certificate telling him he was entitled to, among other things, "high fidelity, no fading, and no static." (Courtesy of Lorraine Moore and Jessica Shedd.)

This memo from KIDO manager Walter E. Wagstaff says KIDO-FM was due to sign on as early as January 10, 1947, with studios in a remodeled guest room on the ninth floor of Hotel Boise. KIDO-FM chief engineer James A. Johntz Jr. built the new station with help from KIDO announcer Vern Moore, who mounted the station's antenna to the neon sign on the roof of Hotel Boise. (Courtesy of Lorraine Moore and Jessica Shedd.)

To All Staff Members:

As KIDO has begun installation of an FM transmitter, and expects to be broadcasting with it soon, you will undoubtedly be asked many questions concerning FM. For that reason, I would like to give you a few facts concerning FM itself, and KIDO's plans in connection with it.

First, may I make this request of every staff member — it is important that we get the names of all present FM set owners in the area, both those with the pre-war, low-band receiving sets and those with the post-war, high-band receiving sets. Therefore if you are asked questions concerning FM by any individual will you please ascertain whether he or she owns an FM receiver, and if so, obtain the name and address and information as to the kind of receiver owned. We hope to build up a mailing list of all FM set owners in our area and propose to send news letters from time to time concerning FM programming and other phases of its operation.

It looks as though KIDO will be broadcasting on its FM station by about January 10. The call letters will be KIDO-FM. For the present, we will be on what is known as interim operation — that is, we will be broadcasting on a lower power and with different facilities than those authorized by the Federal Communications Commission. Our FCC authorization is for 3000-watts but for the present time, we will broadcast on 250-watts through a temporary antenna set up. The transmitting unit will be housed on the 9th floor of the Hotel Boise.

I will not attempt an engineering discussion of the technical difference between FM, and AM, our present method of broadcasting. A number of you have seen the General Electric Company film on the subject and others will have gotten some idea of the technical difference from the radio magazines, but so far as discussions with outsiders are concerned, the questions are likely to be on the practical differences rather than the technical ones. Frequency modulation is a technical improvement in radio broadcasting. The main differences are:

1. FM received on a good receiver set is free from noise and static — both man-made and atmospheric.

2. There is no possibility of receiving two stations at the same time with the resultant interference and "cross-talk" that is sometimes heard on AM.

3. Tone fidelity is much greater, particularly with fine music where a much wider range of frequencies can be faithfully reproduced by FM broadcasting.

KIDO will broadcast on 102.1 megacycles which will be channel #271 on the receiving sets. Pre-war FM sets will not pick up KIDO-FM, because of the fact that the Federal Communications Commission has moved the FM frequency band from that one adopted before the war. All post-war FM sets will pick up KIDO-FM. Inexpensive converters will soon be placed on the market which will enable the pre-war sets to pick up the frequency band on which KIDO will be broadcasting. AM receivers however, cannot be converted satisfactorily and only those people with FM receiving sets will be able to receive Station KIDO-FM.

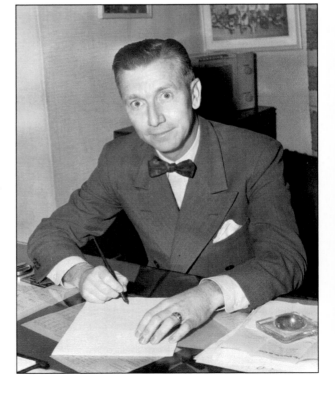

According to Walter Wagstaff, seen here, KIDO-FM would operate six hours daily, simulcasting KIDO-AM from 3:00 p.m. until 6:00 p.m. and running separate programming from 6:00 p.m. to 9:00 p.m. The Musicians Union would not allow some NBC musical programs to be broadcast, so KIDO was in the process of securing licenses as well as transcription and news service contracts for KIDO-FM. (Courtesy of Kris McEntee on behalf of Georgia M. Davidson.)

Sunday's programming on KIDO-FM was somewhat different than what was featured on weekdays. Each Sunday started off with the *FMer's Club*, which was followed by a variety of news and musical programs for different tastes, including opera and even "piano moods." From 8:00 p.m. to 9:00 p.m. most evenings, there were 30 minutes to an hour of concert music. (Courtesy of Lorraine Moore and Jessica Shedd.)

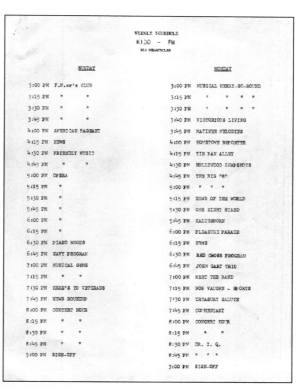

WEEKLY SCHEDULE
KIDO – FM
102 MEGACYCLES

SUNDAY		MONDAY	
3:00 PM	F.M.er'e CLUB	3:00 PM	MUSICAL MERRY-GO-ROUND
3:15 PM	" "	3:15 PM	" " " "
3:30 PM	" "	3:30 PM	" " " "
3:45 PM	" "	3:40 PM	VICTORIOUS LIVING
4:00 PM	AMERICAN PAGEANT	3:45 PM	MATINEE MELODIES
4:15 PM	NEWS	4:00 PM	HOMETOWN REPORTER
4:30 PM	FRIENDLY MUSIC	4:15 PM	TIN PAN ALLEY
4:45 PM	"	4:30 PM	HOLLYWOOD SNAPSHOTS
5:00 PM	OPERA	4:45 PM	THE BIG "8"
5:15 PM	"	5:00 PM	" " " "
5:30 PM	"	5:15 PM	NEWS OF THE WORLD
5:45 PM	"	5:30 PM	ONE NIGHT STAND
6:00 PM	"	5:45 PM	KALTENBORN
6:15 PM	"	6:00 PM	PLEASURE PARADE
6:30 PM	PIANO MOODS	6:15 PM	NEWS
6:45 PM	NAVY PROGRAM	6:30 PM	RED CROSS PROGRAM
7:00 PM	MUSICAL GEMS	6:45 PM	JOHN GART TRIO
7:15 PM	" "	7:00 PM	MEET THE BAND
7:30 PM	HERE'S TO VETERANS	7:15 PM	BOB VAUGHN - SPORTS
7:45 PM	NEWS ROUNDUP	7:30 PM	TREASURY SALUTE
8:00 PM	CONCERT HOUR	7:45 PM	COMMENTARY
8:15 PM	" "	8:00 PM	CONCERT HOUR
8:30 PM	" "	8:15 PM	" "
8:45 PM	" "	8:30 PM	DR. I. Q.
9:00 PM	SIGN-OFF	8:45 PM	" " "
		9:00 PM	SIGN-OFF

KIDO-FM SCHEDULE

TUESDAY		WEDNESDAY	
3:00 PM	MUSICAL MERRY-GO-ROUND	3:00 PM	MUSICAL MERRY-GO-ROUND
3:15 PM	" " " "	3:15 PM	" " " "
3:30 PM	" " " "	3:30 PM	" " " "
3:40 PM	VICTORIOUS LIVING	3:40 PM	VICTORIOUS LIVING
3:45 PM	COMMUNITY SERVICE	3:45 PM	COMMUNITY SERVICE
4:00 PM	HOMETOWN REPORTER	4:00 PM	HOMETOWN REPORTER
4:15 PM	TIN PAN ALLEY	4:15 PM	TIN PAN ALLEY
4:30 PM	HOLLYWOOD SNAPSHOTS	4:30 PM	HOLLYWOOD SNAPSHOTS
4:45 PM	MUSIC IN THE MODERN MOOD	4:45 PM	MUSIC IN THE MODERN MOOD
5:00 PM	" " " "	5:00 PM	" " " "
5:15 PM	NEWS OF THE WORLD	5:15 PM	NEWS OF THE WORLD
5:30 PM	ONE NIGHT STAND	5:30 PM	ONE NIGHT STAND
5:45 PM	NEWS	5:45 PM	KALTENBORN
6:00 PM	TEENS TAKE OVER	6:00 PM	PLEASURE PARADE
6:15 PM	OFF THE RECORD	6:15 PM	NEWS
6:30 PM	WHAT AMERICA IS PLAYING	6:30 PM	BOSTON BLACKIE
6:45 PM	"	6:45 PM	"
7:00 PM	MEET THE BAND	7:00 PM	MEET THE BAND
7:15 PM	BOB VAUGHN - SPORTS	7:15 PM	BOB VAUGHN - SPORTS
7:30 PM	ARMY PROGRAM	7:30 PM	AMERICAN LEGION
7:45 PM	COMMENTARY	7:45 PM	COMMENTARY
8:00 PM	YOURS FOR BETTER MUSIC	8:00 PM	CONCERT HOUR
8:15 PM	" " "	8:15 PM	" "
8:30 PM	" " " "	8:30 PM	" "
8:45 PM	" " " "	8:45 PM	" "
9:00 PM	SIGN-OFF	9:00 PM	SIGN-OFF

Many KIDO-FM programs aired five nights per week, such as *Hometown Reporter* at 4:00, and *Bob Vaughn Sports* at 7:15 p.m. However, other shows, such as NBC commentator H.V. Kaltenborn's newscast, aired on Monday, Wednesday, and Friday only, requiring KIDO-FM to produce its own newscast at 5:45 p.m. on Tuesdays and Thursdays. (Courtesy of Lorraine Moore and Jessica Shedd.)

KIDO-FM SCHEDULE

SATURDAY

	
3:00 PM	HIGH SCHOOL BROADCAST
3:15 PM	" " "
3:30 PM	EDWARD TOMLINSON
3:45 PM	CAMPUS CARNIVAL
4:00 PM	" "
4:15 PM	" "
4:30 PM	F.M. QUIZ SHOW
4:45 PM	RELIGION IN THE NEWS
5:00 PM	FOREIGN POLICY
5:15 PM	" "
5:30 PM	CHRISTIAN SCIENCE
5:45 PM	SOUTH AMERICAN WAY
6:00 PM	HERB'S TO VETERANS
6:15 PM	NEWS
6:30 PM	NAVY SHOW
6:45 PM	SPORTS SCORE BOARD
7:00 PM	MELODY HOUR
7:15 PM	" "
7:30 PM	CAN YOU TOP THIS
7:45 PM	" " " "
8:00 PM	CONCERT HOUR
8:15 PM	" "
8:30 PM	" "
8:45 PM	" "
9:00 PM	SIGN-OFF

Saturdays on KIDO-FM started off with a program called *High School Broadcast* followed by Edward Tomlinson and *Campus Carnival*. Throughout the broadcast day, there were many 15-minute news and talk programs and two half-hour music programs: *Melody Hour*, which aired from 7:00 p.m. to 7:30 p.m., followed by *Can You Top This* from 7:30 p.m. to 8:00 p.m. (Courtesy of Lorraine Moore and Jessica Shedd.)

KIDO celebrated 20 years on the air with a special broadcast on November 7, 1948, from 2:30 p.m. to 3:30 p.m. at the Crystal Ballroom. Arrival was expected by 2:15 p.m. to hear an array of Boise musical artists perform, including Arminta Mathews, Ray Wood, Katheryn Eckhardt-Mitchell, and the Boise Civic Orchestra. (Courtesy of Vern Moore.)

THE MANAGEMENT AND STAFF OF

RADIO STATION KIDO

EXTEND A CORDIAL INVITATION TO YOU AND YOUR FAMILY TO ATTEND A SPECIAL BROADCAST COMMEMORATING THE

TWENTIETH ANNIVERSARY OF KIDO

CRYSTAL BALLROOM, HOTEL BOISE
SUNDAY, NOVEMBER 7, 1948
2:30 TO 3:30 P.M.

YOUR ARRIVAL BY 2:15 P.M. WILL BE APPRECIATED

THE FOLLOWING BOISE ARTISTS WILL BE PRESENTED:

BOISE CIVIC ORCHESTRA
ARMINTA MATHEWS
KATHRYN ECKHARDT-MITCHELL
RAY WOOD

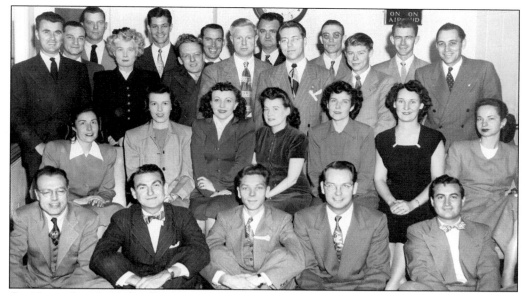

On November 5, 1948, all 26 KIDO employees gathered in the main studio for this group photograph. From left to right, they are (first row) Hal Stewart, Art Letourneau, Vern Moore, Gene Perkins, and Joe Maggio; (second row) Mary Nielsen, Mickie Garrett Birch, Louise Bujaryn, Betty Rogers, LaRue Bates, Catherine Anderson, and Barbara Cornell; (third row) program director Jim McKibbon, Ruth Strange, Roy Pack, Hugh Shelley, Rulon Bradley, Herb Everett, and chief engineer Harold Toedtemeier; (fourth row) Pete Furno, Peter Brooks, Bob Thomas, Ken Stone, Frank Fine, Milt Daniels, and Frank Watkins.

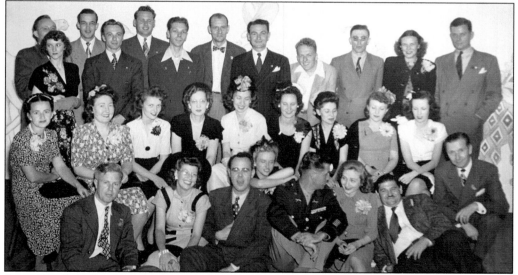

Some KIDO staffers brought dates to the celebration, many of whom were not KIDO employees, making it difficult to identify the individuals seen here, but the photograph did include, from left to right, (first row) Hugh Shelley, Betty and Eugene Perkins, an unidentified serviceman and his date, Billy Phillips, and Walter Wagstaff; (second row) all unidentified; (third row) an unidentified woman and her date, Vern Moore, and Art Letourneau; (fourth row) four unidentified men, Roy Pack, Milt Daniels, an unidentified woman, and Peter Brooks. (Courtesy of Vern Moore.)

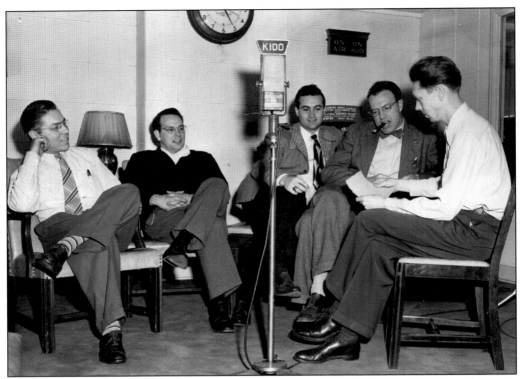

This photograph was selected as the cover of this book because it shows five KIDO employees in the main studio in Hotel Boise consulting over a script. In the foreground is an RCA 44-B classic ribbon microphone, and seated from left to right are Rulon Bradley, Gene Perkins, Joe Maggio, Hal Stewart, and Vern Moore. (Courtesy of Vern Moore.)

THE BOISE CHAMBER OF COMMERCE

AND

RADIO STATION KIDO

INVITE YOU TO VISIT THEIR NEW HOME

AT AN OPEN HOUSE

FRIDAY, SEPTEMBER THIRTIETH

NINETEEN HUNDRED AND FORTY-NINE

2 TO 6 P. M.

CHAMBER OF COMMERCE BUILDING
709 IDAHO STREET
BOISE, IDAHO

In the fall of 1949, KIDO relocated its studios and offices to the second floor of the new Chamber of Commerce Building at 709 ½ West Idaho Street in downtown Boise. On Friday, September 13, a special open house was held from 2:00 p.m. to 6:00 p.m. to allow the public to view the station's new home. (Courtesy of Vern Moore.)

KIDO's new studios featured a modern spacious look with an adjacent glassed-in control room for easy visual cueing. Here, Vern Moore is in front of the RCA ribbon microphone mounted on an adjustable boom stand. The numerous flower arrangements were sent by area businesses and organizations to congratulate KIDO on its beautiful new studios and offices. (Courtesy of Vern Moore.)

KIDO's Chamber of Commerce Building offices were modern in every sense of the word, featuring a front desk with built-in space for a typewriter, recessed lighting, modern ventilation, planter boxes, glass partitions, and even a snazzy linoleum floor design. Owner Georgia M. Davidson's offices remained there for almost 22 years until May 1971. (Courtesy of Kris McEntee on behalf of Georgia M. Davidson.)

Jack Link began his radio career on KIDO as a Boise High School *Highlights of the Airwaves* student reporter. After graduation in 1943, he enrolled at Boise Junior College. He joined the US Army Air Corps and was stationed in Yuma, Arizona, where there was a radio station on base. After his military service, Link enrolled in the broadcasting program at Washington State University in Pullman, Washington. In the summer of 1947, he worked for KCID in Caldwell, Idaho, which had just signed on the air. Upon graduation from Washington State in 1948, Link returned to KCID, where he eventually became the program director. In 1950, he married Ella Mays, the choir director at Caldwell High School, and that summer, for their honeymoon, the two went to Chicago, where he enrolled in the NBC Summer Radio-Television Institute. Upon returning to Boise, Link paid a visit to KIDO general manager Walter Wagstaff and told him about his experience with television at NBC. The next year, 1951, Link was hired away from KCID and came to work at KIDO, soon replacing Jim McKibbon as program director. (Courtesy of Jack J. Link.)

Five

THE MOVE TO 6-3-0

After World War II ended, KIDO's position as Boise's dominant radio station was challenged by three competitors: KGEM, KDSH, and KFXD. KIDO responded by applying for 5,000 watts at 630 on the dial. After a lengthy FCC hearing, KIDO signed the new facility on the air on March 18, 1951, complete with a special commemorative program broadcast live from the Boise Junior College Auditorium from 3:00 p.m. to 4:00 p.m. (Courtesy of Vern Moore, Lorraine Moore, and Jessica Shedd.)

You are cordially invited to attend a special program to be broadcast from the Boise Junior College Auditorium on Sunday afternoon, March 18, 1951 from 3 to 4 o'clock

The program will present outstanding musical artists, and will dedicate KIDO's new transmitting plant which commences operation on that date with power of 5,000 watts, on a frequency of 630 kilocycles.

Kindly present this card at door.

Bring guests if you like.

Doors will close promptly at 2:50 P.M.

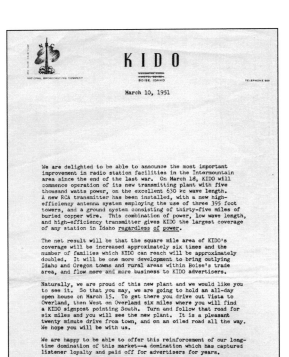

KIDO
BOISE, IDAHO

March 10, 1951

We are delighted to be able to announce the most important improvement in radio station facilities in the Intermountain area since the end of the last war. On March 18, KIDO will commence operation of its new transmitting plant with five thousand watts power, on the excellent 630 kc wave length. A new RCA transmitter has been installed, with a new high-efficiency antenna system employing the use of three 395 foot towers, and a ground system consisting of thirty-five miles of buried copper wire. This combination of power, low wave length, and high-efficiency transmitter gives KIDO the largest coverage of any station in Idaho regardless of power.

The net result will be that the square mile area of KIDO's coverage will be increased approximately six times and the number of families which KIDO can reach will be approximately doubled. It will be one more development to bring outlying Idaho and Oregon towns and rural areas within Boise's trade area, and flow more and more business to KIDO advertisers.

Naturally, we are proud of this new plant and we would like you to see it. So that you may, we are going to hold an all-day open house on March 15. To get there you drive out Vista to Overland, then West on Overland six miles where you will find a KIDO signpost pointing South. Turn and follow that road for six miles and you will see the new plant. It is a pleasant twenty minute drive from town, and on an oiled road all the way. We hope you will be with us.

We are happy to be able to offer this reinforcement of our long-time domination of this market—a domination which has captured listener loyalty and paid off for advertisers for years.

Cordially yours,

Walter E. Wagstaff

WEW:mn

On March 15, 1951, KIDO held an open house at its new transmitter. According to this March 10, 1951, letter from manager Walter E. Wagstaff, anyone interested in seeing the plant was directed to take Vista Avenue to Overland Road and then go six miles west to Cloverdale Road. It was another six-mile drive south to the new transmitter on Hubbard Road. (Courtesy of Vern Moore.)

The new transmitter site featured three widely spaced 395-foot towers with a modern cinderblock transmitter building in front of the middle tower. As this ad from 1951 touts, KIDO now covered more square miles and reached more people than any other radio station in Idaho, regardless of power. (Courtesy of Larry Cain.)

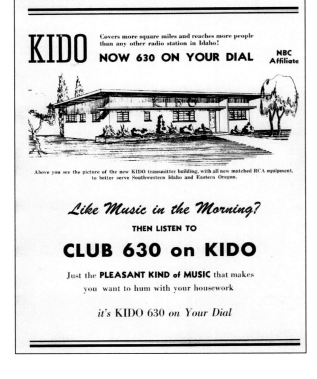

KIDO's new towers required proper lighting and painting to mark them as an obstruction to aircraft. Each 395-foot tower was equipped with a beacon with "aviation red"-colored shades. The beacon had to flash 20 to 40 times per minute. The towers were to be painted international orange and white as per this order issued on April 17, 1952. (Courtesy of Kevin Godwin, Leland Eichelberger, and Lucas Babin of Peak Broadcasting.)

The new towers also required an Air Navigation Facility Certificate issued by the Civil Aeronautics Administration. KIDO's certificate stated that the towers had been inspected and were rated "suitable for the use of civil aircraft of the United States." At 395 feet tall, KIDO's new towers were immediately adopted as a landmark to help guide aircraft in their landing approach to the Boise Municipal Airport and Gowen Field. (Courtesy of Kevin Godwin, Leland Eichelberger, and Lucas Babin of Peak Broadcasting.)

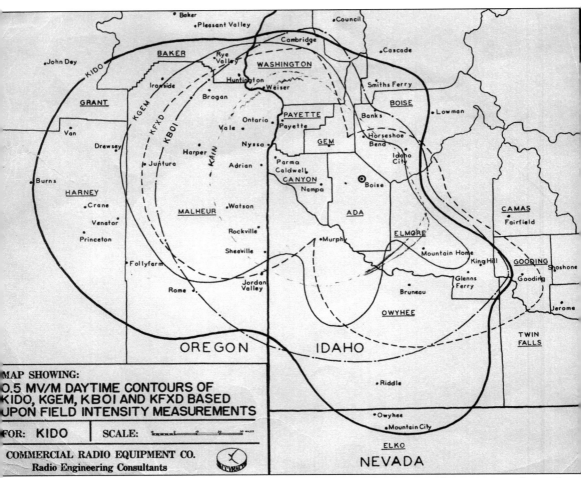

For a time, KIDO's coverage was indeed larger than any other Boise radio station, as this mid-1950s coverage map clearly shows. With 1,000 watts at 580 on the dial for KFXD and 10,000 watts at 1140 on the dial for KGEM, both stations had to protect several high-powered stations in northern and central California, while KIDO only had to protect co-located stations on the 630 frequency in Denver and Reno. However, in 1951, the combined population of Nampa and Caldwell justified putting a good signal over these two communities day and night. And that's just what KIDO's new directional antenna system did. Several years later, KFXD increased its daytime power to 5,000 watts non-directional at 580 on the dial and bettered KIDO's coverage. However, when this map was made in the early 1950s, KIDO was the king of coverage in Boise. (Courtesy of Gilbert Rose Jr.)

The 1950s were a time of growth for KIDO. While KIDO-FM failed to make an impact and signed off the air in the early 1950s, KIDO-AM's move to 630 on the dial and power increase to 5,000 watts was a success. As an NBC affiliate, listeners could count on KIDO to be their window to the world for the latest news and the full slate of NBC programs. (Courtesy of Kevin Godwin and Cindee Scholfield of Peak Broadcasting.)

In 1956, KIDO sponsored the popular Community Club Awards, where local service clubs could earn money by shopping at KIDO sponsors. This buyer's guide was given to all club members and provides a fascinating look at life in Boise in the mid-1950s. (Courtesy of Kevin Godwin and Cindee Scholfield of Peak Broadcasting.)

You are saving
proofs-of-purchase for:

Organization

Chairman's Name

Chairman's Address

Chairman's Phone No.

BE SURE TO READ ALL DETAILS IN THIS BUY-
ER'S GUIDE. DON'T MISS ANY OPPORTUNI-
TIES OF INCREASING YOUR DOLLAR-VOLUME.

Copyright 1956, Community Clubs Services, Inc.

Club members were urged to write down the name, address, and phone number of their organization's chairman and then consult the buyer's guide for more ways to make money for their club or charity. (Courtesy of Kevin Godwin and Cindee Scholfield of Peak Broadcasting.)

Each week, KIDO on-air personalities gave away $50 in proof-of-purchase credits to 15 different KIDO listeners who could answer questions correctly. (Courtesy of Kevin Godwin and Cindee Scholfield of Peak Broadcasting.)

Listen to
KIDO
For Questions asked by KIDO
Personalities. Club members who
answer correctly, will receive

$50 Proof - of - Purchase

$750
In Credits
Given Away
Each Week

One of KIDO's longtime advertisers was the Gem Canning Company of Emmett, whose Indian Gem brand fruits and vegetables were grown locally. In the early 1960s, children could get free signage to open up their own Cherokee Punch stand and make extra pocket money by selling the tasty fruit punch in paper cups. (Courtesy of Kevin Godwin and Cindee Scholfield of Peak Broadcasting.)

Home Dairies was another KIDO advertiser, that said that its milk was "known for its finer flavor." In the 1950s, home delivery of milk and other dairy products was commonplace, but grocery stores such as Albertson's and M&W Markets were making shopping more convenient and accessible. Home Dairies' slogan, "At your store or at your door," was used in all of its advertising, including radio and television. (Courtesy of Kevin Godwin and Cindee Scholfield of Peak Broadcasting.)

The 1957 model cars were introduced in the fall of 1956 and a brand new 1957 Chevrolet two-door sedan was priced at less than $2,000 at Larry Barnes Chevrolet. Club members could get double dollar credit if they bought the Community Club Special new or used car. (Courtesy of Kevin Godwin and Cindee Scholfield of Peak Broadcasting.)

Stinker Stations, at Sixteenth and Front Streets in Boise, offered "cut-rate" gasoline at all three of its locations, including the Nampa and Caldwell stations. Club members had many ways to get proof-of-purchase dollars, including catching a Stinker employee not cleaning your windshield or giving you a smile, both of which were worth a $1,000 proof-of-purchase bonus. (Courtesy of Kevin Godwin and Cindee Scholfield of Peak Broadcasting.)

General Electric offered prospective buyers a free demonstration of GE Customline appliances in their home or at the store. Any club member who bought something received a free GE portable television set, a prestigious product for a family to own in 1956. (Courtesy of Kevin Godwin and Cindee Scholfield of Peak Broadcasting.)

Sherm Perry Fine Furniture was located at 609 North Orchard Street and offered $250 in additional bonus credit for any drapery installation and triple bonus credit on all purchases. (Courtesy of Kevin Godwin and Cindee Scholfield of Peak Broadcasting.)

By 1956, the era of the TV dinner had arrived. Chet's "famous" frozen convenience foods were touted as being "Shu-r-r GOOD," and were available in both stores and restaurants. The selection included meat pies, dinners, tamales, and even desert pies available in "family size" or as "pies for two." (Courtesy of Kevin Godwin and Cindee Scholfield of Peak Broadcasting.)

KIDO's owner, Georgia Davidson, was born in rural Canyon County near Notus, Idaho. At one time, her father, James B. Newport, was president of the Black Canyon Irrigation District. The Parma area is still known for its wonderful onions and this advertisement said that any bag of Black Canyon Produce potatoes or onions failing to make US No. 1 grade would be replaced free of charge. (Courtesy of Kevin Godwin and Cindee Scholfield of Peak Broadcasting.)

Boise had a number of fine men's clothing stores including the Men's Wardrobe; Riley's, "the Store for Men;" and Le Roux Men's Wear. It did not take much for a man to get $100 in bonus points for his wife's club, he simply had to visit Le Roux and sign the CCA register. (Courtesy of Kevin Godwin and Cindee Scholfield of Peak Broadcasting.)

Whitehead Drug Stores had three locations in 1956: at Eighth and Main Streets, in Vista Village, and in the Franklin Shopping Center. Co-owner Blaine Casper later changed the name of the Vista location to Casper's Vista Pharmacy. In 1956, Whitehead offered free delivery, charge accounts, and Scottie Rite Stamps—not to mention "perfect" service. (Courtesy of Kevin Godwin and Cindee Scholfield of Peak Broadcasting.)

At Peerless Dry Cleaners, if a club member opened a new delivery account, they received $100 in bonus credits. (Courtesy of Kevin Godwin and Cindee Scholfield of Peak Broadcasting.)

There were a lot of jewelry stores in Boise, two of which were located a block away from each other on Eighth Street. Carlton's is now gone, but Molenaar's is still in business. The three stores featured in this ad, including Williams Jewelry on North Orchard Street, were all part of an association called Jewel House Jewelers. (Courtesy of Kevin Godwin and Cindee Scholfield of Peak Broadcasting.)

Vic's Countryside Eggs is still in business in the Boise area. In 1956, their slogan was "Our Ad is Inside the Shell." (Courtesy of Kevin Godwin and Cindee Scholfield of Peak Broadcasting.)

Union Farm and Garden Supply on North Orchard Street made the transition from farm to city life in Boise by offering gas-powered lawn and garden equipment to the public as well as rose bushes and potted shrubs and even cage birds, for which KIDO Community Club Award participants could get a $50 bonus credit. (Courtesy of Kevin Godwin and Cindee Scholfield of Peak Broadcasting.)

Holsinger's Boise Music sold Baldwin pianos and electric organs and rented school band and orchestra instruments. In the early 1960s, Franklin Holsinger was a music teacher at Boise High School. Later, he was involved in the ownership of Music Ads, a local jingle company headed by the late bandleader and musician Gib Hochstrasser. (Courtesy of Kevin Godwin and Cindee Scholfield of Peak Broadcasting.)

The Royal Crown Bottling Company was located on Capital Boulevard just north of the west entrance to Julia Davis Park. Through the giant picture windows, locals could watch the soda pop bottles travel the conveyor belt as they were filled and capped. Flavors included RC Cola, Nehi Orange, Upper-10, and Par-T-Pak large bottles, which often contained drink mixes. (Courtesy of Kevin Godwin and Cindee Scholfield of Peak Broadcasting.)

In the mid-1950s, KIDO newsman Vern Moore interviewed many celebrities and sports figures, although the man being interviewed by him here is unidentified. (Courtesy of Vern Moore.)

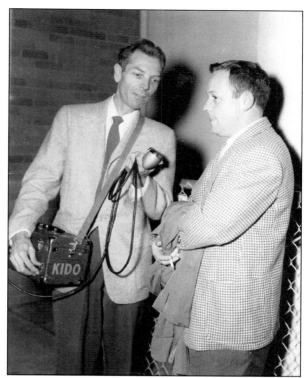

KIDO had the latest in audio recording equipment, and Moore's small case carried a small battery-operated reel-to-reel tape recorder with a built-in microphone connector. A shoulder strap allowed Moore to carry the unit easily. The unidentified man being interviewed had a suitcase sporting a sticker from Hotel Der Kaiserhof of Porta Westfalica in upper Austria. (Courtesy of Vern Moore.)

In early 1952, Vern Moore was about to complete his military service in the Korean War, which he had left KIDO two years earlier to volunteer for. Returning as a civilian, he needed a job, so he wrote manager Walter Wagstaff at KIDO, letting him know when he might be released. As a Navy veteran who served in both World War II and the Korean War, Moore always had an excellent relationship with all branches of the military, which helped his credibility as a reporter. Here, Moore interviews several members of the Army but he appears to be keeping one eye on the 35-foot rotor blade on the Hiller H23B helicopter. This model H23B raven was used primarily for training in the Korean War and had a speed of 96 miles per hour and a range of 224 miles. (Courtesy of Vern Moore.)

K I D O

CHAMBER OF COMMERCE BUILDING ★ BOISE, IDAHO

TELEPHONE 660

WALTER E. WAGSTAFF
GENERAL MANAGER

April 21, 1952

V. E. Moore, RMNC, USNR
Box 19, U. S. Naval Station
Navy No. 230 %PM
Seattle, Washington

Dear Vern:

Well, I must admit that once you did break down and write a letter you made it a long and newsy one. I very much enjoyed reading it and was very much interested in the information that it contained.

Of course, I had no hope that you would be able to pin down a date as to when you might be released but your detailed discussion of the probabilities in that direction certainly leads to the happy conclusion that it "won't be long now". As things develop, I would appreciate your keeping me informed as the probable date of your return will continue to have a definite bearing on our plans here.

Speaking of plans, you have likely already heard that we are fairly bursting with them at the present time. Last month we applied for a TV station and I can assure you that it is a very serious, rather than a merely tactical application. I make this statement because of the fact that our competitors are going around town with a "KIDO just put in this application as window dress and has no intention of going through with it etc." line of malarky. We have the equipment on order from RCA with an guarantee that shipment will be made within thirty days after we receive a CP and we have made a substandial cash deposite thereon. Clearly, we are not fooling.

I will not go into very much detail as it is pretty completely and accurately covered by the enclosed newspaper story. An interesting sidelight might be the Statesman's attitude on this thing, in view of the fact that this story appeared on the left hand side of the front page and was followed up by a very laudatory Editorial, copy of which is also enclosed.

One detail that the newspaper story does not give is the exact location. Perhaps you will recall where Virgil McGee built his new house (above Hills Village). Perhaps you will also recall that a few hundred yards Southeast of his house there is a water tank. Immediately beyond the water tank is a rather abrupt hill. We purchased a strip of ground along the road which includes the top of the hill, and the lower elevation lying immediately beyond it. Therefore, we will be able to take advantage of the hill for added antenna height and level off the lower part for

Walter E. Wagstaff was the general manager of KIDO when he wrote this letter to Vern Moore in April 1952, during Moore's final stint in the Korean War. In the letter, Wagstaff informs Moore of KIDO's recent FCC filing for Channel 7 television. Wagstaff says KIDO is "not fooling" and has even put down a deposit on new equipment from RCA. He then describes the transmitter site above Boise Hills Village as being near the area where Virgil McGee built his new home. McGee was the longtime manager of the Hotel Boise, so KIDO had a good relationship with him. In the letter, Wagstaff makes reference to an editorial in the *Statesman* newspaper congratulating them on being first to apply for a television station. KIDO had a good relationship with the *Statesman*, and their favorable comments sent a very positive message to the business community that KIDO was indeed serious about bringing television to the Treasure Valley. (Courtesy of Vern Moore, Lorraine Moore, and Jessica Shedd.)

building and parking area. It is really an ideal spot—being readily
accessible to a hard surfaced road, water, and power—in addition to the
natural elevation which will give ideal antenna height.

Teddy and I recently spent some time in Kansas City and Tulsa seeing
operational procedure, studio and control room layouts etc. In a couple
of weeks Teddy, Jack Link and I are going to San Francisco and study
the three stations there. I don't know whether or not you have met
Jack Link. He was at KCID while you were here and came over last
Summer. We slipped him into Jim McKibben's spot when Jim left and he
is proving to be a wonderful guy. He is not only one of the most likable
fellows you could possibly meet, but is a hard worker and is very
competent. I know you will enjoy working with him.

As to the fourth paragraph in your letter.....the part about "whether
we really want you back......I don't even intend to dignify that
question by making a reply to it. Just get yourself, your wife, your
son, your civilian clothes, your discharge papers, and get the hell back
here as fast as you can. In the meantime, if you spend some time in
Seattle take advantage of any opportunities that you get to hang around
KING-TV and observe what is going on. Teddy and I were up there last
year and were very cordially treated by Bob Preib the guy in charge of
the TV operation. If you find that you are going to be in Seattle,
I am certain that a letter from either of us would open the door for
you and you would have every opportunity to pick up a lot about
operational procedures. Needless to say, our problem of training
people at KIDO-TV when KIDO-TV happens is going to be a very real one.
The station certainly cannot afford to travel everyone who will be
involved to far places to study operations. We will just have to
train four or five guys as a nucleus and go on from there. So seize
any opportunities you might get to make observations.

Of course all of this does not mean that we are forgetting old lady
radio. While Miss TV is a very glamorous new mistress, old lady radio
is still going to have to buy the vegetables, make the beds, and spread
butter on the bread for quite some time to come.

Mrs. Davidson, Mary, et al send their best. By all means keep us
informed of your situation.

Best regards,

Walter E. Wagstaff

WEW:mn

In 1952, television was brand new, and in Wagstaff's letter to Moore, he mentions that he and chief engineer Harold Toedtemier went to Kansas City and Tulsa to learn about television station operations and would soon travel to San Francisco with Jack Link to visit the three television stations there. Moore must have made a comment about his impending return to KIDO, posing the question "Do you really want me to come back?" To that, Wagstaff rather bluntly confirmed that they indeed did want him back, telling him to "get yourself, your wife, your son, your civilian clothes, and get the hell back here as fast as you can!" The last couple of lines are rather telling, as Wagstaff wrote, "Of course all of this does not mean we are forgetting old lady radio. While Miss TV is a very glamorous mistress, old lady radio is still going to have to buy the vegetables, make the beds, and spread the butter on the bread for quite some time to come." (Courtesy of Vern Moore, Lorraine Moore, and Jessica Shedd.)

Six

KIDO-TV

Jack Link started at KIDO radio in 1951 and was promoted to program director when Jim McKibben left. When KIDO-TV signed on the air on July 12, 1953, Link moved to television. After filling in on the "weather picture" one night, the sponsor liked him so much that they asked him to do the weather on a permanent basis. As the Purina Weatherman, Link had his own stationery, which also indicated his "incidental occupation." (Courtesy of Jack J. Link.)

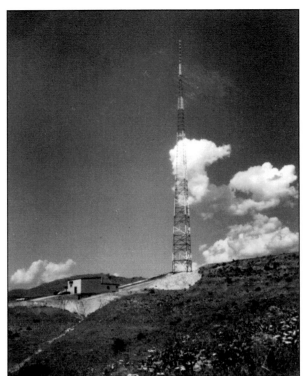

This rare photograph of the KIDO-TV Crestline Drive building and transmitter site shows the 350-foot self-supporting tower that held Channel 7's six-bay antenna. The site was just above Boise Hills Village on the hill just east of the water tank. The tower was taken out of service in the fall of 1956 when Channel 7 increased its power and installed a new tower at Deer Point near Bogus Basin. (Courtesy of Vern Moore.)

Below, chief engineer Harold Toedtemeier tunes up the new, state-of-the-art 10,000-watt RCA transmitter on Crestline Drive. Note the huge vacuum tube in the cabinet to the right. (Courtesy of Vern Moore.)

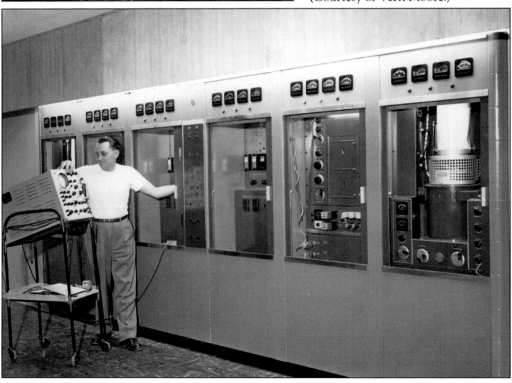

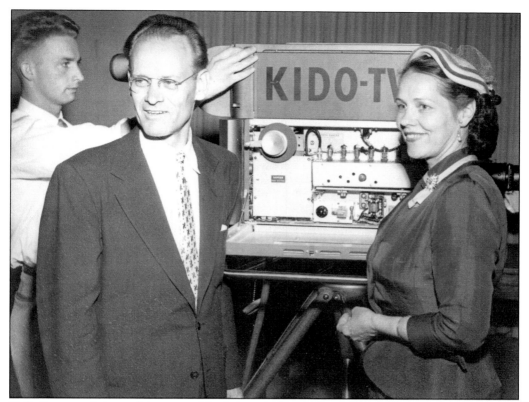

Philo Farnsworth (center), known as "the father of television," moved to Idaho in 1918 and attended Rigby High School. While there, he showed teacher Justin Tolman blackboard sketches for an electronic television system, which were later reproduced in a successful patent-infringement lawsuit against RCA. Farnsworth was in Boise on July 12, 1953, saying he was "thrilled and honored" to be present for the KIDO-TV premiere. (Courtesy of Kris McEntee on behalf of Georgia M. Davidson.)

The versatile Vern Moore was Harold W. "Teddy" Toedtemeier's right-hand man in building KIDO-TV. Here, Moore (right) adjusts the audio section while Teddy checks out the video section of the new transmitter. (Courtesy of Vern Moore.)

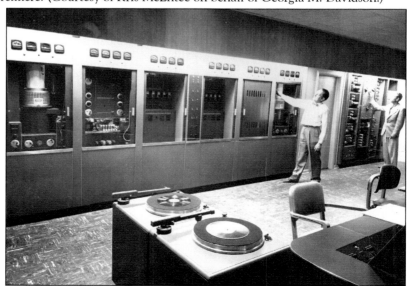

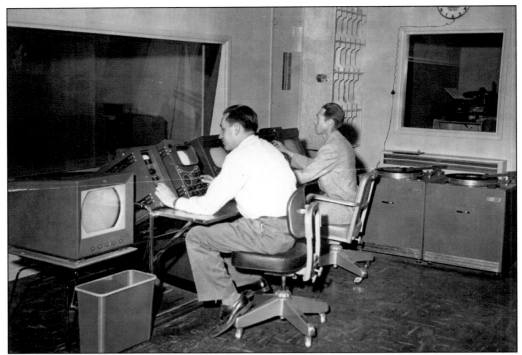

The KIDO control room was small by today's standards, with much of its gear designed as portable, individual pieces, with carrying handles on the top. Here, Toedtemeier adjusts the video levels while Moore assists running the audio. Note the record-storage bins right next to the two giant transcription turntables. (Courtesy of Vern Moore.)

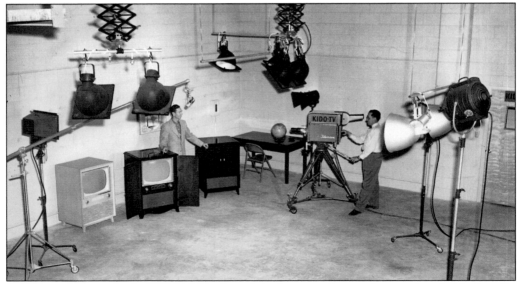

The main on-air studio for KIDO-TV had a polished cement floor and painted cinderblock walls. The news "set" was a small wooden table with a globe on it. The newscaster sat on a folding chair. Here, Vern Moore does a live commercial for television sets, using an RCA ribbon microphone on a long "boom" stand. Harold Toedtemeier operates the RCA camera. (Courtesy of Vern Moore.)

A handsome young Vern Moore poses before the camera in this publicity shot for KIDO-TV. Moore was the first person to appear live on Idaho television, as well as Idaho's first news "anchorman." (Courtesy of Vern Moore.)

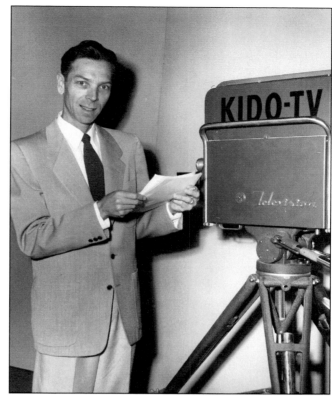

The *Shell News* featured Vern Moore seated in front of a giant Shell Oil sign. There was even a miniature version of the sign on Moore's nameplate, along with a miniature gasoline pump to the right. The news sponsor also received a live commercial delivered by the newscaster himself, who in this case was promoting Shell's X-100 Motor Oil. (Courtesy of Vern Moore.)

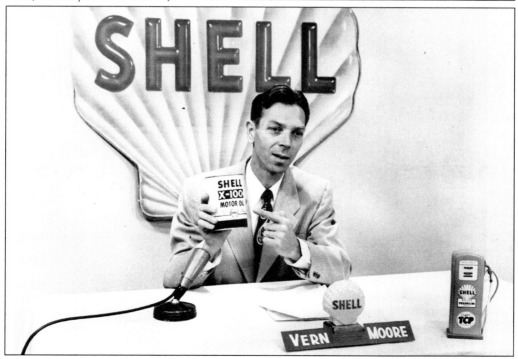

In the mid-1950s, Jack Link reported *The Weather Picture* on KIDO-TV and is seen here wearing his Sunfreze Ice Cream and Arden Milk hat to promote his weather sponsor. Note the primitive weatherboard on wheels, with a clear plastic cover on the weather map allowing Link to add temperatures and show "lunk-head lows," which is how he described approaching lows. (Courtesy of Jack J. Link.)

The *Idaho Television Guide* was a 16-page weekly publication listing the weekly program schedules for KIDO-TV Channel 7 and KBOI-TV Channel 2. It sold for 10¢, and the back cover asked the question, "Over 13,000 people in our area are now enjoying their own TV sets . . . why not you?" (Courtesy of Vera Cederstrom.)

This *Idaho Television Guide* covered the March of Dimes *Givaganza*. KIDO-TV featured Willard Waterman, "the Great Gildersleeve," who offered the services of prominent Boiseans to the highest bidder. At the bottom is a plug for NBC's *You Bet Your Life*, starring Groucho Marx, who sent a telegram to KIDO-TV on its first day of operation wishing the station success, adding "I played Boise . . . and I hope your success is better than mine!" (Courtesy Vera Cederstrom.)

THE DIMES MARCHED ON TV!

Both channel 2 and channel 7 had big nights for the March of Dimes! The former was a talent show with bids that amounted to more than $1700. KIDO-TV (Channel 7) imported "The Great Gildersleeve" (Willard Waterman) of radio fame, to star in a telecast: "Gildersleeve's Givaganza," in which the services of prominent Boiseans were offered to the highest bidders. Mayor R. E. Edlefsen, for instance, volunteered to "bake cakes or anything," and Councilwoman Anna Hettinger said she "would baby sit but would prefer something like teaching square dancing." . . . Sheriff Spud turned in a hat-full of small change amounting to about $150, all contributed voluntarily from kiddies. Total take from the "Givaganza" was more than $3700. Televiewers as well as talent were sleepy the next day. Both shows lasted most of the night.

KBOI PRESS CONFERENCE

Every Friday over Channel 2 at 9:00 p. m.—with Dave Johnson as moderator, interviewing a public official or prominent people, on questions of the day. Among his guests have been Robert Smylie, Idaho Attorney General; Theron Gough, publisher of the Parma Review; G. H. Oppenheimer of the Meridian Times; Kenneth Colley of the Wilder Herald; Asher B. Wilson of Twin Falls; Brigadier General Walsh.

GROUCHO, master of the impromptu quip, is head man on the ever popular "You Bet Your Life" program, presented every Thursday at 8:00 p. m. over KIDO-TV, channel 7.

"Fifer's Fair is on the Air!" was the slogan used on radio and television by the popular Boise furniture store that called its store at the foot of Depot Hill "Television City" and its showroom at Eleventh and Main Streets "Television Corner." The store sold six different lines, including Admiral, Motorola, Zenith, and Philco. (Courtesy of Vera Cederstrom.)

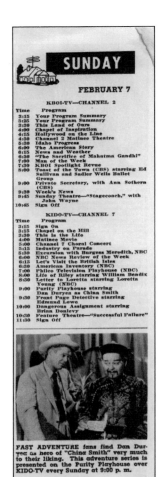

Boise's Sunday television viewing in the early 1950s began at 3:15 p.m. Later that evening, viewers could watch CBS's *Toast of the Town*, starring Ed Sullivan, at 8:00 p.m. on KBOI-TV or *Life of Riley*, starring William Bendix, on KIDO-TV. At 9:00 p.m., NBC aired *Letter to Loretta* with Loretta Young. (Courtesy of Vera Cederstrom.)

In 1955, KIDO-TV had "seven outstanding on-camera personalities," including, clockwise from top left, program director and weatherman Jack Link; late-night newscaster Del Lundbom; early evening newscaster Vern Moore; on-camera talent Jim Cowen; deep-voiced film editor Bill Harvey, who later went on to host both news and weather on Channel 7; women's show host Louise Dunlap; and Jess Keys, who played host on the popular kid's show *Sheriff Spud*. (Courtesy of Vern Moore, Lorraine Moore, and Jessica Shedd.)

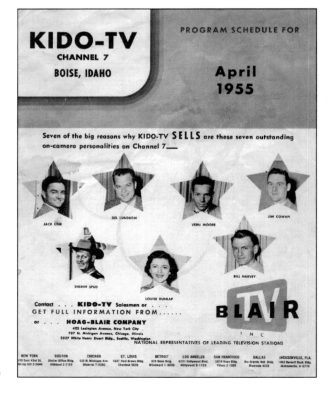

One of KIDO's biggest stars was *Sheriff Spud*, played by Channel 7's sign painter Jess Keyes. The show ran six days a week starting at 4:30 p.m. and at 5:00 p.m. on Saturdays. Keyes replaced Gene Perkins, who left Channel 7 to accept a job in another market, only to return and find the role of Sheriff Spud taken. (Courtesy Jack J. Link.)

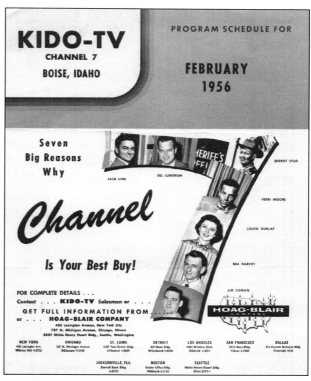

Clete Lee of KIDO hosted this local quiz show that featured a "man in the moon" who asked the in-studio audience to "applaud when my eyes are bright." It was sponsored by a canned foods company. Lee, whose real name was Cletus Leo Schwitters, was also a Hollywood actor, using the name Byron Keith. He appeared in *The Stranger*, directed by Orson Wells, and in numerous other pictures. (Courtesy of Vern Moore.)

Robert Nagel, the owner of the popular Boise retail store Idaho Camera, did his own live commercials on KIDO-TV in the mid-1950s. Nagel's son Pat remembers going to the KIDO-TV studios on Crestline Drive to watch his father advertise this Brownie Movie Camera Kit. Note the rear-projection screen, which makes it appear Nagel is doing the commercial from the store, and the metal copy-board, where the script he was reading was mounted. (Courtesy of Pat and Dennis Nagel and Idaho Camera.)

This interesting view from inside the KIDO-TV control room shows how the studio appeared to the director. Note the vu-meter to the right and the small video monitor showing the off-air signal. On the far right is the large garage door that could be opened for vehicles to enter. Here, Robert Nagel promotes Kodak snap cameras. (Courtesy of Pat and Dennis Nagel and Idaho Camera.)

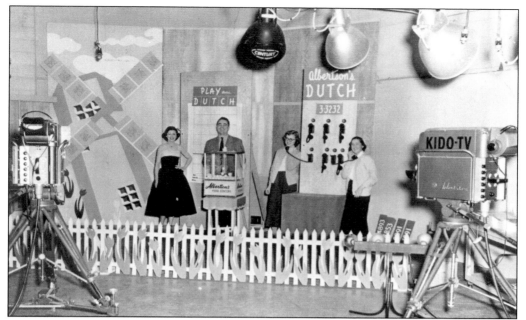

Jack Link and Louise Davis hosted this early KIDO-TV game show called *Play Dutch*. It was sponsored by Albertson's Food Centers. Note the five-digit telephone number on the set and the bank of seven wall-telephones the two female assistants were answering. The giant studio lights illuminated the set so the RCA camera could capture a good picture. (Courtesy of Kris McEntee on behalf of Georgia M. Davidson.).

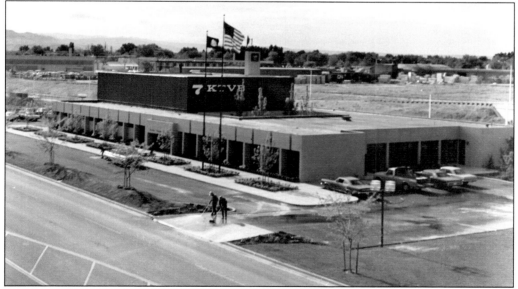

KIDO-TV changed call letters to KTVB on February 1, 1959. The station's technical operations remained at the original Crestline Drive studios, while the sales and management offices continued from 709 ½ West Idaho Street. In May 1971, both functions were finally combined in a beautiful new state-of the art facility at 5407 Fairview Avenue. Here, concrete finish work on the west entrance is being completed. (Courtesy of Vern Moore.)

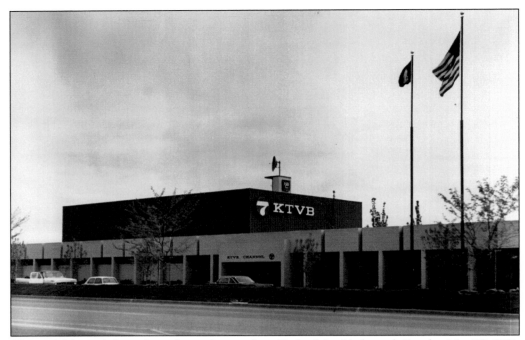

Channel 7 hosted three days of open houses from Friday May 21 through Sunday May 23, 1971. Georgia Davidson's son in law, vice president and general manager Robert E. Krueger, said the building cost $487,500 and was designed by the architectural firm of Cline, Smull, Hamill, Shaw, and Associates. It boasted 20,401 square feet of operational space, with a 70-by-55-foot studio, the largest in Idaho. (Courtesy of Vern Moore.)

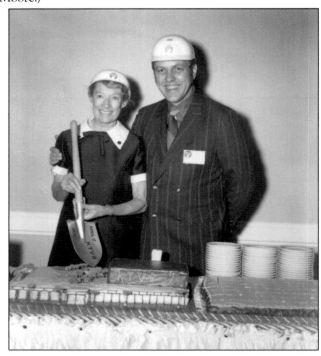

Owner Georgia M. Davidson and Robert E. Krueger celebrate the ground-breaking for the new KTVB studios on April 17, 1970. Davidson had now been in broadcasting for 42 years and the construction of this facility marked another major accomplishment. She would sell KTVB to King Broadcasting of Seattle, who took control exactly 10 years later on April 17, 1980. (Courtesy of Kris McEntee on behalf of Georgia M. Davidson.)

Seven
THE "LIVE FIVE"
DAYS ON VISTA

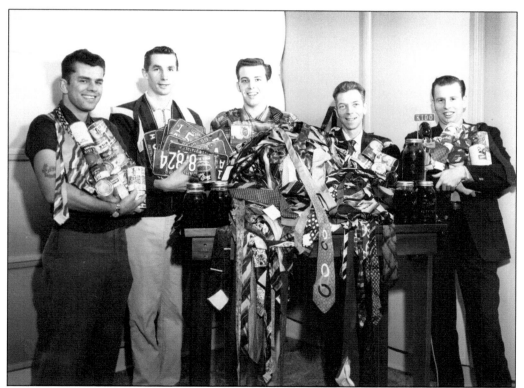

KIDO Radio was sold to William E. Boeing Jr. of Seattle on February 1, 1959. The station's on-air staff soon became known as the "Live Five," a group that included, from left to right, "Deacon Del" Chapman, "Sparkplug" Ron Sanford, "Just Plain" Dick McGarvin, Vern "Pappy" Moore, and "Jazbo" Jim Blossey. The group is seen here at a station charity drive to collect canned food, license plates, and ties. (Courtesy of Vern Moore)

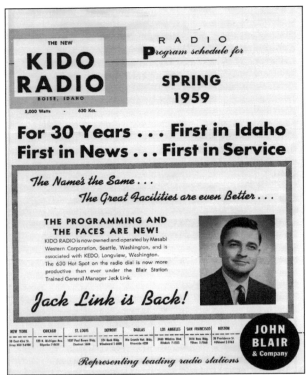

Jack Link was the program director of Seattle's KING-AM and had interviewed Bill Boeing Jr. at the hydroplane races. Boeing approached Link about managing KIDO and a deal was struck at a hydroplane race at Lake Mead. Link began his career with Boeing on January 31, 1959, and continues to work for him, 53 years later. In 1959, the headline on this KIDO program schedule said it all: "Jack Link is back!" (Courtesy of Jack J. Link.)

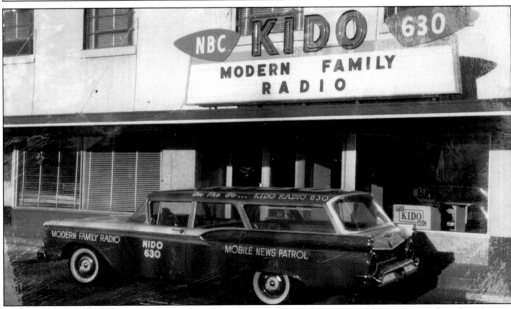

In early 1959, Jack Link announced that KIDO's studios and offices would be relocated to the Hoppie Building at Vista Avenue and Overland Road. Temporary studios were built at the transmitter site at Cloverdale and Hubbard Roads. In the spring of 1960, KIDO began broadcasting from the front window of 1528 Vista Avenue. This early photograph shows the Vista Avenue studios and offices and the 1959 Ford "Mobile News Patrol" wagon. (Courtesy of Jack J. Link.)

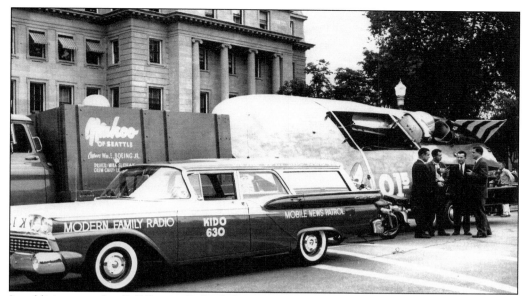

In addition to radio, Bill Boeing Jr. had also invested in hydroplanes. Here, the Boeing team's Czechoslovakian driver, Mira Slovak (second from left, holding the cup), chats with Boise mayor Robert Day (third from left) in front of the capitol building. KIDO manager Jack Link (far right) arranged for Boeing's hydroplane, *Miss Wahoo*, to drive though the streets of downtown Boise in celebration of the team's recent cup victory. (Courtesy of Jack J. Link.)

Mira Slovak was chief pilot for Czechoslovakian Airlines when he flew his plane "under the radar" to West Germany and requested political asylum. Arriving in the United States, he was hired as Bill Boeing Jr.'s pilot and drove Boeing's hydroplane, *Miss Wahoo*. In 1959, he won both the President's Cup and the Lake Mead Cup. This Wahoo Racing Team sticker calls the hydroplane "U101.5," which was KETO-FM's frequency. (Courtesy of Jack J. Link.)

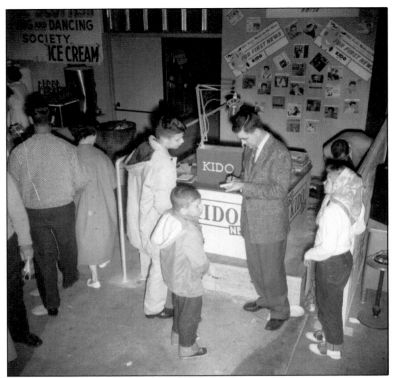

KIDO was always on location, doing many remote broadcasts. Here, Jack Link signs an autograph in May 1959. (Courtesy of Jack J. Link.)

The KIDO staff included chief engineer John Maxon; program director Vern Moore; salesmen Jim Davidson and Cap Ingalls; announcers Ray Whitworth, Dick McGarvin, and Jack Valley; traffic director Janie Fisher; continuity director Louise Davis; and receptionist Gail Johnson. Here, from left to right, announcers Del Chapman (sawing), Dick McGarvin, and Ron Sanford make a live appearance at Chain Saw Headquarters. The man to the right is unidentified. (Courtesy of Jack J. Link.)

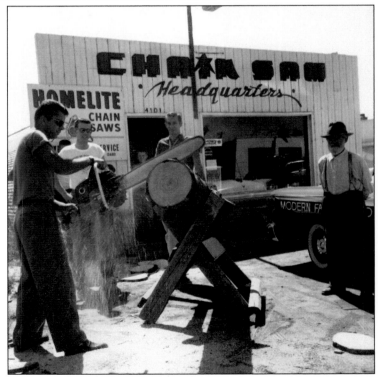

The KIDO announcing crew takes a break from sawing logs. Here, from left to right, are announcers Del Chapman, unidentified, Ron Sanford, Dick McGarvin, and program director Vern Moore. (Courtesy of Jack J. Link.)

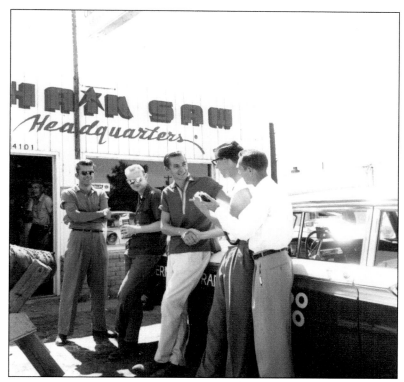

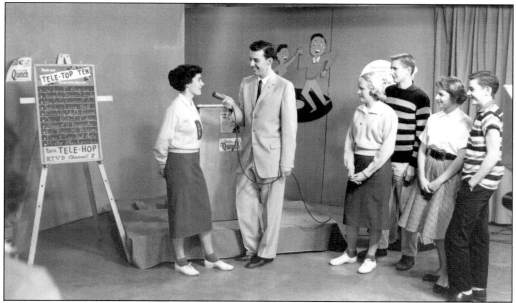

KIDO's Dick McGarvin also hosted *Teen Tele-Hop* on KTVB Channel 7 in the early 1960s, which was an American Bandstand–type sock-hop that took place at the KTVB studios on Crestline Drive and was part of the popular afternoon show *Periscope*. High school and junior high school students from all over the valley came to the studio to dance on camera. The show aired on Fridays at 4:30 p.m. from 1960 to 1961. (Courtesy of Kris McEntee on behalf of Georgia M. Davidson.)

The "Live Five" posing with their boss, station manager Jim Davidson (third from left), now consisted of, from left to right, Bob Swanson, Dick McGarvin, Del Chapman, Lon Dunn, and program director Jim Blossey. The KIDO staff shows off the beards they were growing to commemorate the 1963 Idaho Territorial Centennial. (Courtesy of James Blossey.)

This 1962 photograph includes staff members, from left to right, (first row, sitting) Donnella "Girl Friday" Shulz, Jack Link, Vern Moore, and Jim Davidson; (second row) Grace Farley-Ingalls, Bob Swanson, Jim Cowen, Janie Fisher, Cap Ingalls, John Maxon, Lon Dunn, and Jim Blossey. (Courtesy of Vern Moore.)

In this early-1965 photograph, the KIDO crew enjoys a few pitchers of beer and a cigarette or two. On the left side of the table are Shirley A. Thompson and four unidentified men. On the right side are, from front to rear, announcer Jack Thompson, Vern Moore, Jim Davidson, Lon Dunn, Del Chapman, and an unidentified man. (Courtesy of Vern Moore.)

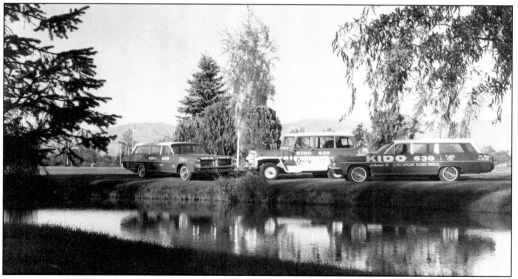

The 1963 Idaho Territorial Centennial provided KIDO with an ideal opportunity to promote its 630 dial position by calling the station "Centennial 63." The KIDO fleet of radio-equipped news vehicles included two Pontiac station wagons and the station's Jeep engineering vehicle. Note the verbiage on the different vehicles, including KIDO 630 spelled backwards on the front of the Pontiac to the left. (Courtesy of Jack J. Link.)

Vern Moore, seen here interviewing Lt. Gov. Jack Murphy, started at KIDO in 1935 as a transmitter operator. He listened to shortwave news broadcasts in Morse code, translated them, and then telephoned the secretary at KIDO, who typed the information into news copy for Dooley Riddle to read. Moore moved up to writing and reporting the news and became a voice people knew and trusted for 41 years. (Courtesy of Vern Moore.)

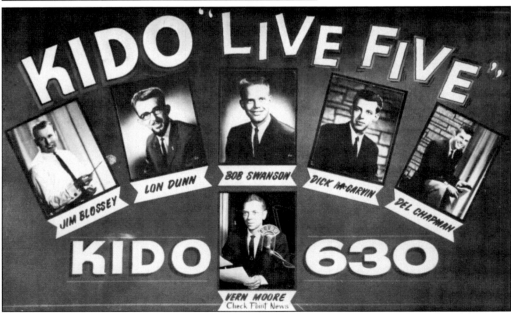

This 1963 poster identifies the "Live Five" and shows the order they appeared on air, with "Jazbo" Jim Blossey from 5:30 a.m. to 9:00 a.m., "Lucky" Lon Dunn from 9:00 a.m. to noon, Bob Swanson from noon to 4:00 p.m., Dick McGarvin from 4:00 p.m. to 7:00 p.m., and "Deacon" Del Chapman from 7:00 p.m. to midnight. News director Vern Moore did extended newscasts in the morning, at noon, and in the evening, and hosted KIDO's *Check Point News* throughout the day. (Courtesy of Jack J. Link.)

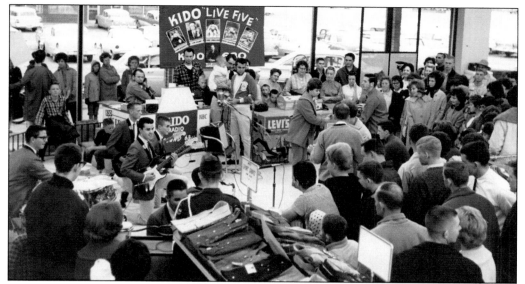

Announcer Del Chapman started out at KIDO doing afternoons. After Jim Blossey moved to mornings, Dick McGarvin moved to afternoons and Chapman moved into the evening slot, allowing him to book bands by day. Among the groups that Chapman managed were the Fabulous Chancellors, the Mystics, and the Naturals, featuring fellow disc jockey Bob Swanson. A bearded Chapman is seen here between the two microphones, wearing his KIDO 630 sweater. (Courtesy of Jack J. Link.)

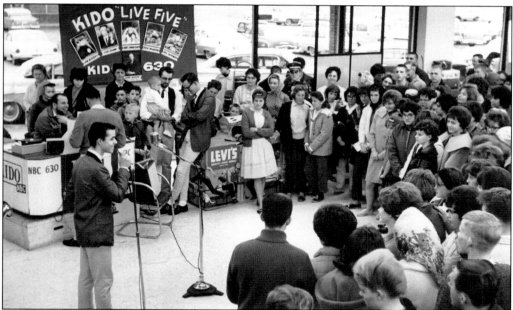

Phil Volk of the Fabulous Chancellors speaks into the microphone at this KIDO live remote at the Merc Department Store in Boise's Franklin Shopping Center. Later, Volk was a member of the successful national act Paul Revere and the Raiders. At the KIDO console is Jim Blossey, speaking to Blossey with his back turned is Del Chapman, and holding the baby is announcer Lon Dunn. (Courtesy of Jack J. Link.)

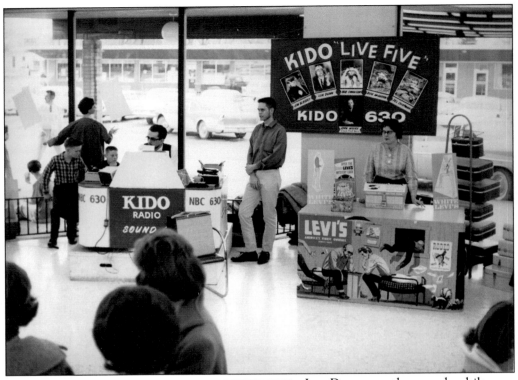

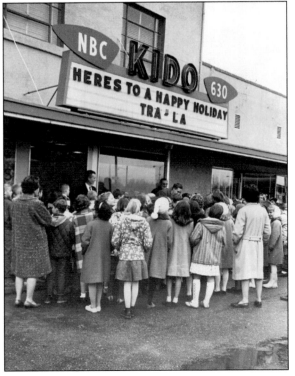

Lon Dunn runs the console while Bob Swanson wears the featured product of the remote, white Levis. In 1963, Del Chapman started the Trocadero Ballroom on Overland Road in Boise. The Fabulous Chancellors, Dick Cates, and the Mystics all played there and were managed by Chapman. The club lasted until 1966, when problems with kids drinking in nearby yards forced it to shut down. (Courtesy of Jack J. Link.)

When the Beatles exploded onto the music scene, KIDO was at the forefront. By early 1964, KIDO had changed their slogan to "Boise's Key Station" and also changed Del Chapman's *Treasure Valley Original Top 30* to allow kids to vote for their five favorite songs. This December 1964 photograph shows a group of McKinley Elementary students crowding around the front of the Vista Avenue studios singing Christmas carols. (Courtesy of Jack J. Link.)

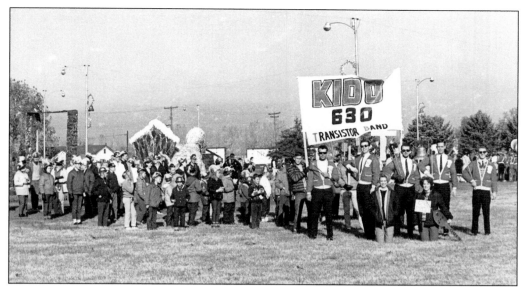

The KIDO "Transistor Band" featured the "Live Five" marching in local parades holding transistor radios all tuned to KIDO. Listeners joined in too. Seen here in November 1964 are, from left to right, (kneeling) an unidentified female and "Girl Friday" Donnella Shulz holding the KIDO "key;" (standing) announcers Del Chapman, Dick McGarvin, Lon Dunn, Bob Swanson, and Jack Thompson. (Courtesy of Jack J. Link.)

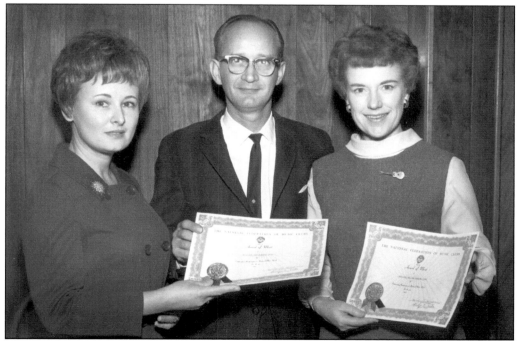

Don Cederstrom was KIDO's chief engineer when he met his future wife, Vera Sternling, who was the traffic director at KEST. In this 1967 photograph, Don (center) and Vera (right) receive awards for helping with Music Week, an annual event that started in Boise. Vera is still involved with Music Week and continues to carry on its mission. (Courtesy of Vera Sternling.)

Don Cederstrom was born in Grand Rapids, Minnesota, and actually had Judy Garland as his babysitter as a child. The family later moved to the Mesabi Range, an area in Northeast Minnesota rich in iron ore deposits. From 1963 to 1976, he worked for KIDO and the Mesabi Western Corporation. Throughout his life, Cederstrom loved to tinker with things; when he was still in high school, he built this motor for his bicycle. (Courtesy of Vera Sternling.)

Cederstrom moved to Twin Falls in the early 1950s and became the chief engineer for KLIX Radio. He then built KLIX Television, signing it on the air on May 30, 1955. After moving to Boise, he formed Custom Recording Company, where he often recorded local high school bands, orchestras, and choirs on location. Here, Cederstrom and his wife, Vera, monitor the levels of a live recording of a local music group. (Courtesy of Vera Sternling.)

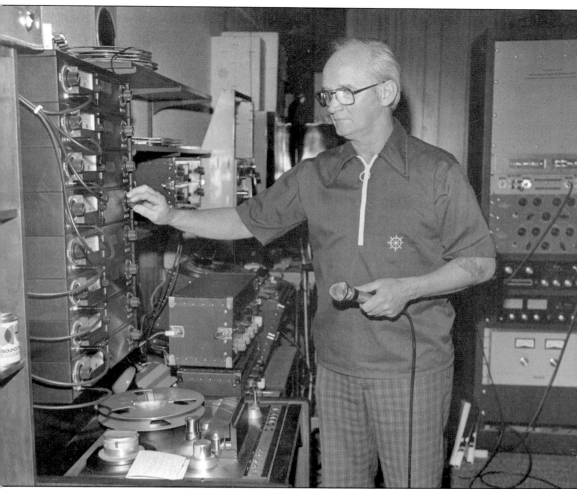

When Don Cederstrom first moved to Boise in 1962, he worked for Harold Morrison's film-cleaning business. When Gib Hochstrasser's Music Ads Jingle Company needed help with its new Ampex four-track recorder and custom four-channel control board, they called in Cederstrom, who quickly fixed the problem and was hired on full-time. When John Maxon left KIDO in 1963, Cederstrom took over as chief engineer, serving in that capacity until the summer of 1976, when Western Broadcasting bought KIDO from Mesabi Western Corporation. During that time, Cederstrom had expanded Custom Recording Company into a full-blown recording studio, where local and regional bands often recorded their "master" recordings, which were then pressed into vinyl records, or duplicated onto cassettes or compact discs, which Custom Recording could also produce. Upon Cederstrom's retirement in 2010, his longtime friend and business partner, Paul Franklin, bought the business. Here, Cederstrom checks the levels on one of his early eight-track recorders. Sadly, Cederstrom passed away on January 5, 2011, at the age of 84. (Courtesy of Vera Sternling.)

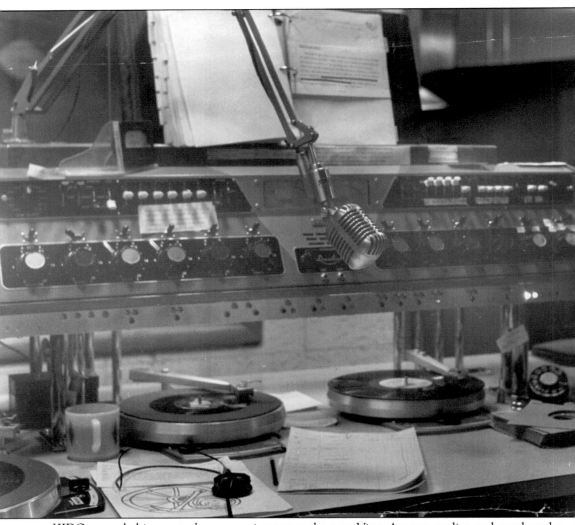

KIDO upgraded its control room equipment at the new Vista Avenue studios and purchased a state-of-the-art Gates "Dualux" dual-channel control board. It featured nine mixing channels, including one network and one remote input, which were specially designed to accommodate telephone lines. It was a large console, weighing more than 200 pounds, and had impressive technical specifications even though it used vacuum tubes. The custom-built raised pedestal it sat on allowed for two turntables to be located underneath, with a third off to the left side, as well as start buttons and indicator lights below each mixer. The Shure Model 556-S Unidyne II microphone featured "shock-mounting" for quiet operation. (Courtesy of the Idaho State Historical Society.)

Eight

THE PROMOTIONS AND NEWS LEADER

KIDO handed out a lot of small novelty gifts to listeners and clients alike to help establish a relationship with them. The front of this particular card reads: "Here's your Happy Ghost from KIDO. Open *carefully* so that he doesn't get away." The inside of the card says it all. (Courtesy of Jack J. Link.)

Oops! YOU LET HIM GET AWAY!

But...
KEEP TUNED TO KIDO
6-3-0!
Your Key to Better Listening
FOR MORE FUN!

Who would think to put a sewing kit in a matchbook? KIDO did, handing out hundreds of these "darn-it" kits that featured six different colors of thread, two shirt buttons, a sewing needle, and a safety pin. The outside cover of the kit had the station's call letters, dial position, and logo, plus an individual "lucky number" that could be announced on the air. (Courtesy of Jack J. Link.)

KIDO believed in advertising in other mediums as well. These are a series of newspaper ads from the mid-1960s touting the fact that KIDO was "your NBC affiliate" and featured eight sports features and 21 reports a day. NBC's *Monitor* was part of that advertising campaign too; it was touted as "your weekend companion" and aired every Saturday and Sunday on KIDO. (Courtesy of Jack J. Link.)

Back in 1962, most service stations were locally owned. This postcard was mailed to all Atlantic-Richfield (Arco) stations reminding them that KIDO was promoting the Goodyear tires they sold. According to KIDO, Goodyear tires and Richfield Boron gasoline were a great combination. (Courtesy of Jack J. Link.)

Chevron dealers got this postcard from James M. Davidson of KIDO reminding them that Vern Moore read the news sponsored by Chevron at 7:05 a.m. each weekday. Dealers were encouraged to tie in their own local advertising around the popular feature, and to listen to KIDO, which many service stations did. (Courtesy of Jack J. Link.)

On August 1, 1966, KIDO began broadcasting 24 hours a day. The "radio-gram" above allowed KIDO salespeople to write or type a custom message within the allowed space and attractively "frame" their message. It could then be mailed as a postcard or used as a "shelf-talker," or point-of-purchase reminder, of featured products or specials advertised over KIDO. (Courtesy of Jack J. Link.)

"You've heard it on KIDO" cards were printed in bold colors like bright purple and used reverse type for maximum contrast. This card jumps off the shelf and reminds shoppers that indeed they had heard about the store's product or special on KIDO. These innovative ideas helped KIDO win the battle of print versus radio. (Courtesy of Jack J. Link.)

110

The KIDO electric bird with a microphone and headphones was dropped from the station's letterhead and weekly music charts in 1964. However, it was still used on this postcard that chief engineer John Maxon sent out to confirm reception of KIDO's signal in distant areas outside of Boise. (Courtesy of Jack J. Link.)

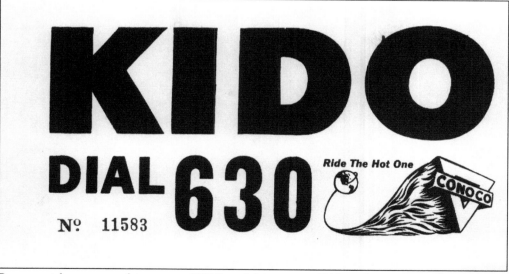

Bumper stickers were nothing new to KIDO, and this vintage 1960s sticker was specially numbered, allowing KIDO to call out that number over the air. It featured the Conoco gasoline logo in the bottom right corner with Conoco's latest slogan, "Ride the Hot One." (Courtesy of Jack J. Link.)

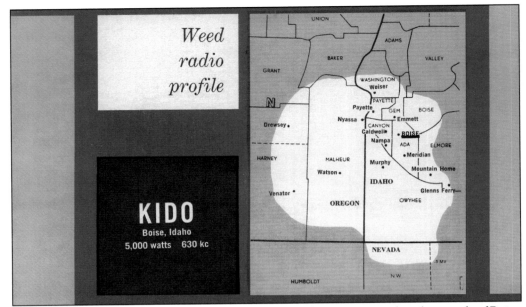

For a time, Weed Radio Corporation was KIDO's national representative for sales outside of Boise. This sales piece from the early 1960s offers a fascinating look at the Boise market though the eyes of an outsider. In addition to a coverage map on the front cover, the piece features market data indicating that agriculture was "the backbone of the economy." (Courtesy of Jack J. Link.)

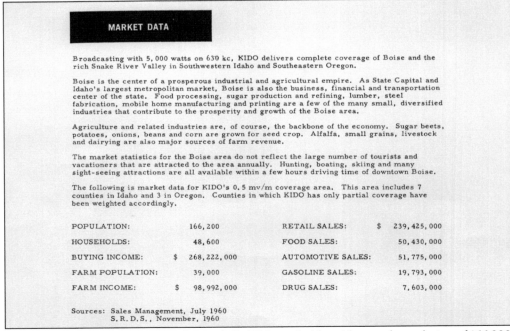

At the time, the entire Boise area boasted 48,600 households, with a total population of 166,200. As can clearly be seen here, agriculture was a major industry in the Boise area in the 1960s, and it still is. Major department stores listed included C.C. Anderson's, Falk's, Cash Bazaar, J.C. Penny, The Mode, Sears, and Montgomery Ward. (Courtesy of Jack J. Link.)

MARKET CHARACTERISTICS

Principal Pay Days: Thursdays and Fridays

Principal Shopping Days: Thurs, Fri, Sat.

Stores Open Evenings: General - Mon, Fri.
 Food - Every evening

Major Dept. Stores: C.C. Anderson, Falk's
 Cash Bazaar, J.C. Penney, The Mode, Ltd.,
 Sears, Montgomery Ward

Major Variety Stores: J. J. Newbury, Shelton's,
 Cornet, S. H. Kress, Woolworth

Major Food Chains: Safeway, Albertson's, Okay,
 Idaho Food King, M. & W. , A.G. , Buy-Low

Major Drug Chains: Save-Mor, Skaggs, Latah,
 Whitehead, Save-On

Working Hours:
 Factory -- 7:00 am - 4:00 pm
 Office -- 8:00 am - 5:00 pm
 Dept. Stores -- 9:30 am - 6:00 pm

PROGRAMMING

KIDO's programming is designed for family listening. The music, personalities and features are specifically scheduled for the audience of the hour.

In the morning KIDO's programs are bright, informative, and non-frantic. Weather, sports, news and time reports are scheduled at frequent intervals along with a special farm segment for the rural audience.

Later in the morning and in the early afternoon hours, KIDO's programming is beamed to the housewife. Special features such as "Homemaker's Hit Parade" and "Household Hints for the Harried Housewife" are highlighted during this period.

Later in the afternoon, in honor of the "fender benders" KIDO steps up the pace with more current hits and new releases plus frequent time, weather and traffic reports.

In the evening, the early hours are devoted to the younger members of the KIDO audience with late evening time reserved for music for easy listening.

KIDO news service is the best in the market. The KIDO mobile unit, listener news tip service and short wave monitor facilities provide complete, up-to-the-minute coverage of all important news. Local newscasts are presented on the half-hour with NBC network news on the hour.

KIDO offered block programming, with news and upbeat music in the morning, "housewife" programming during the middle of the day, time and traffic for the "fender bender" period of afternoon driving time, early evenings devoted to younger listeners, and the late evening reserved for "easy listening" music. (Courtesy of Jack J. Link.)

SPEAKING OF RESULTS —

When KIDO lends support to a campaign - either for an advertiser or for a community project - the response is both immediate and enthusiastic. The following are typical of the results produced by KIDO.

Sun Valley Sportswear used radio for the first time to advertise a special sale - and used KIDO exclusively. The following is a quote from a letter sent to KIDO by a Sun Valley Sportswear executive. "Recently we purchased some time on your station for the purpose of advertising a sale we were having. At the same time, we placed an ad in the local newspaper. The newspaper ad was dropped after the first day due to the tremendous response we received from your radio listeners."

Martin Tire Company reported that a customer drove 200 miles to purchase tires. The reason given was that the customer felt he had come to know and trust the company through their campaign on KIDO.

Operation Clean Up was initiated by KIDO after a particularly serious flood. Volunteers were requested to help the many senior citizens of Boise whose homes were swamped with mud. At the appointed hour -- 8:00 am on a Saturday morning -- over 100 volunteers appeared on the scene with picks, shovels and other equipment to aid in this community service.

Idaho Food Products used KIDO as their only radio advertising outlet. After the first month of their campaign - Idaho Food Products reported an 18% increase in sales over the previous month.

"Fun With Pop" night was created by KIDO to bolster attendance at the local ball club's games and to stimulate family activity. KIDO's promotion attracted more than 1,000 new spectators to cheer on the home team. Two weeks later, the station sponsored two more "Fun With Pop" nights at the local Drive-In Theatre. Both nights attendance hit an all-time record sell-out!

Electro-Dome Appliance Dealer sponsored a KIDO all-day remote broadcast from their store. During the course of the broadcast they attracted a sizeable crowd and sold 40 major kitchen appliance units as a direct result of the KIDO promotion.

The back page of the Weed Corporation profile featured testimonials of KIDO's "pulling power" for advertisers, including a brief write-up on something KIDO called "Fun with Pop" night. Two weeks later, the report says, KIDO sponsored two more "Fun with Pop" nights at local drive-in theaters that resulted in record sellout attendance both nights. (Courtesy of Jack J. Link.)

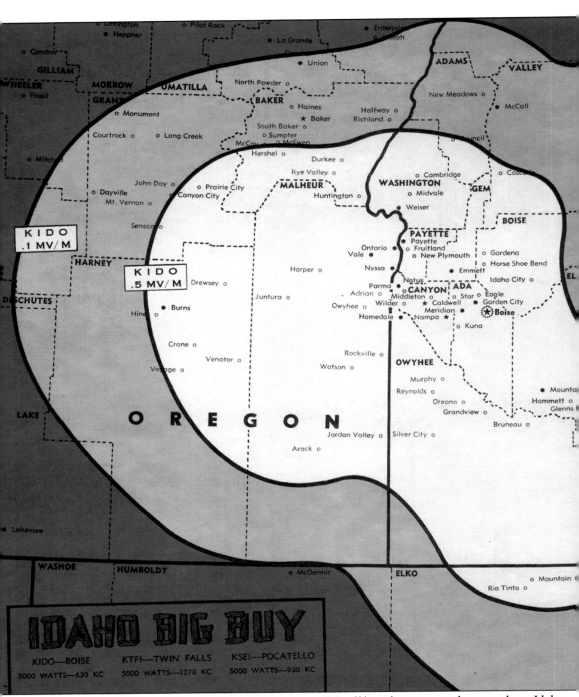

The Idaho Big Buy consisted of three 5,000-watt, NBC-affiliated stations in three southern Idaho markets. According to this mid-1960s brochure, KIDO in Boise, KTFI in Twin Falls, and KSEI in Pocatello reached 639,100 people, which was equivalent to the 49th largest metropolitan-area population in the United States. The coverage area of all three stations combined was impressive, and since all three were old-line NBC affiliates, they probably did reach similar demographics in

their respective markets. The John Blair Company had great success selling KIDO, KTFI, and KSEI as a package buy. The back page of the brochure indicates that there were 172,681 "radio homes," with over $1 billion in consumer buying power. The combined populations of the three southern Idaho towns made up 88 percent of Idaho's entire population. (Courtesy of Jack J. Link.)

KIDO's Rate Card No. 10 from October 1966 indicates that the station's national representative changed to the Savalli/Gates Company. By 1966, Boise's population was 107,100 and there were 307,100 people in KIDO's basic coverage area. At the top of the rate card is a deal for $8 for a 60-second commercial run in a fixed position, with saturation plans of 50 spots per week available for as little as $4.75 per commercial. (Courtesy of Jack J. Link.)

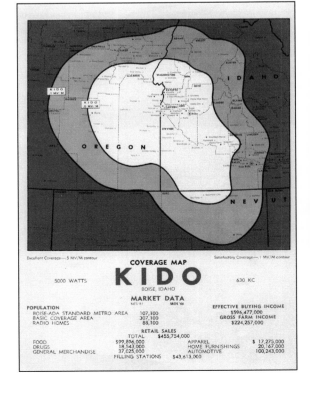

KIDO's coverage map from 1966 shows its daytime signal reached all the way to Burns, Oregon, to the west and near to Gooding, Idaho, to the east. There were 88,100 "radio homes" in KIDO's coverage area alone, and total retail sales were now over $455 million. (Courtesy of Jack J. Link.)

KIDO's sales literature said it reached 17 counties in "Idaho's largest market area." The station had five major attributes it was very proud of, including "better music and superior on-the-air-salesmen." The other four attributes included a full-time local news and farm director, NBC Radio Network programming from Boise's first radio station and first network affiliate, community awareness and participation since 1928, and full service 24 hours a day. (Courtesy of Jack J. Link.)

Even as late as 1976, KIDO printed a formal program schedule listing all programs, local news, and weathercasts, and even noted which announcer was on duty. The spring 1967–winter 1968 schedule showed that Larry Taylor started his morning show *Funrise* at 5:00 a.m. with news, farm reports, and KIDO's "morning assignment"—a 30-minute block of weather, world news, Idaho news, and sports, all anchored by Vern Moore. (Courtesy of Jack J. Link.)

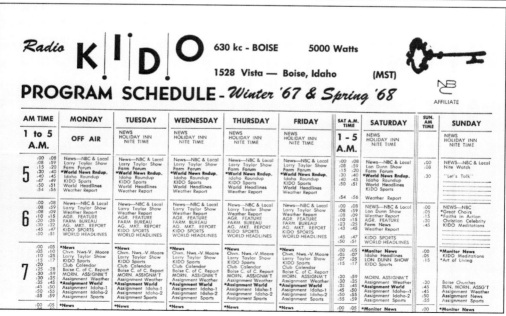

Vern Moore, KIDO's news director, was respected by all. In this photograph from the mid-1960s, Moore and other reporters are seen meeting with Idaho governor Robert E. Smylie in his office. Moore is seated in the foreground to the right. Seated to his right is a young Sal Celeski, the longtime news director of KTVB Channel 7 television. (Courtesy of Vern Moore.)

During Moore's 41-year career as a broadcaster and a journalist, he probably interviewed most of Idaho's important figures. Famous Idaho potato king and industrialist J.R. Simplot (right) was no exception, and is seen here being interviewed by Moore in the mid-1960s. (Courtesy of Vern Moore.)

Nine
THE OWYHEE PLAZA DAYS

KIDO Radio
BOISE'S KEY STATION
Dial 63 · · · NBC

RATE CARD No. 13
Effective April 1, 1969

TAP MONTHLY RATE CARD
5 a.m. to Midnight
(Total Audience Plan-Released in 30 days)

TIMES	60 SEC.	30 SEC.	10 SEC.
1 to 19	$5.50	$4.15	$2.75
20 to 49	4.50	3.40	2.25
50 to 99	3.50	2.65	2.00
100 to 199	3.10	2.30	1.75
200 or more	2.90	2.10	1.65

12-MONTH CONTRACT
10% Discount on TAP Only!

7-DAY SATURATION TAP

25-60 Seconds	$3.45
25-30 Seconds	2.60
25-10 Seconds	1.95

SPECIFIED ANNOUNCEMENTS AND
PROGRAMS — RATE CARD No. 10

**KIDO doesn't sell TIME alone —
KIDO sells PRODUCTS & SERVICES!**

24-HOURS-A-DAY
RATES — MIDNIGHT TO 5 ON REQUEST
Telephone 344-8661

KIDO · RADIO
1109 Main • 5th Floor • Owyhee Plaza
P.O. Box 8087 • Boise, Idaho 83707

In late 1968, KIDO radio moved from 1528 Vista Avenue to new studios and offices on the fifth floor of the Owyhee Hotel, now known as the Owyhee Motor Plaza. This rate card was one of KIDO's first at the new location and featured some lower rates to encourage the use of "Total Audience Plan" rates. The rate card also said, "KIDO doesn't sell time alone – KIDO sells products & services!" (Courtesy of Jack J. Link.)

Radio KIDO

630 kc - BOISE 5000 Watts
5TH FLOOR OWYHEE PLAZA
1109 MAIN STREET BOISE, IDAHO

Summer & Fall '69

NBC AFFILIATE

AM TIME	MONDAY	TUESDAY	WEDNESDAY	THURSDAY	FRIDAY	SAT A.M.	SATURDAY	SUN. AM TIME	SUNDAY
12 to 5 A.M.	OFF AIR	NEWS—LSW "KIDO" NITEWATCH	NEWS—LSW "KIDO" NITEWATCH	NEWS—LSW "KIDO" NITEWATCH	NEWS—LSW "KIDO" NITEWATCH	1 - 5 A.M.	NEWS—LSW "KIDO" NITEWATCH		NEWS—LSW "KIDO" NITEWATCH

KIDO — 630 — "Voice of the Seattle Pilots" *(This schedule subject to change during play by plays)*

Boise's KEY Station — Now! Full Service Radio — 24 Hrs. a Day

NEWS CODE: N - NBC L - LOCAL NEWS S - SPORTS W - WEATHER * — NETWORK PROGRAMMING

KIDO's published program schedule for the summer and fall of 1969 showed the many changes that had taken place since the move from Vista Avenue to the Owyhee Plaza. The overnight program was now known as *Nitewatch* and, for a time, was sponsored by several local heating oil companies and called *Oil Heat Comfort Hours*. From Tuesday through Friday, overnight announcer Ben Raider now hosted two hours of the morning show from 5:00 a.m. to 7:00 a.m., at which time the Lon Dunn show began. Ernie Allen's mid-day program started at 10:00 a.m. and continued until 4:00 p.m., when Bob Brenna took over until 5:00 p.m. Announcer Doug West, whose real name was Westervelt, filled in for Brenna during *Evening Assignment* until 5:45 p.m., and then played music until 6:00 p.m., at which time Brenna took back the controls until midnight. From 7:00 p.m. to 8:00 p.m., KIDO continued to air Gardner Ted Armstrong's *The World Tomorrow* and public affairs programming. Music programming resumed at 8:00 p.m. (Courtesy of Jack J. Link.)

BOISE'S KEY STATION
BRINGING YOU BRONCO FOOTBALL

KIDO RADIO • 63

Former KIDO sales manager Andy Enrico says that KIDO's regular coverage of Boise State University took place after the school became a four-year college. He recalls sitting with Walt Lowe, who did the play-by-play, and Cap Ingalls, who did the color commentary, in the old wooden Bronco Stadium press box. This 1970 ticket shows the newly constructed Bronco Stadium, which only had two-story seating on one side of the stadium. (Courtesy of Jack J. Link.)

New prices for Boise State football tickets went into effect on August 1, 1970. Season tickets were $20 and reserved seats were going for $4 per game. The Bronco Athletic Association (BAA) and President's Club memberships could be acquired by contacting the business office at the new varsity center. The Broncos did not play the University of Idaho in 1970, but KIDO did carry all of the home and away games that season. (Courtesy of Jack J. Link.)

Andy Enrico was hired as an account executive at KIDO by Cap Ingalls in 1968, when the station moved to the Owyhee Plaza. According to Enrico, "We had a great air team of Lon Dunn, Ernie Allen, Mike Lesh, and Ken Jewell." In 1970, Andy became sales manager, staying until early 1975, when he joined a local ad agency. He then founded a successful real estate agency, which he still operates today. (Courtesy of Andy and Linda Enrico.)

Among the many celebrities Vern Moore got to interview was Hollywood actor Robert Taylor, who for a time was one of the unsuccessful applicants for Channel 6 Television in Nampa. Taylor disclosed their plans for the new station at a press conference in Boise on February 21, 1968, which may have been when this photograph was taken. On June 8, 1969, Taylor died of lung cancer at the age of 57. (Courtesy of Vern Moore.)

KIDO's Rate Card No. 11 became effective on January 1, 1970, and showed no real increase in 60-second spot rates over its last rate card three years earlier, and a decrease in 30-second spot rates. Station manager James M. Davidson's name was still printed on the rate card, something few competitive stations would dare to do, as many of them changed managers frequently. (Courtesy of Jack J. Link.)

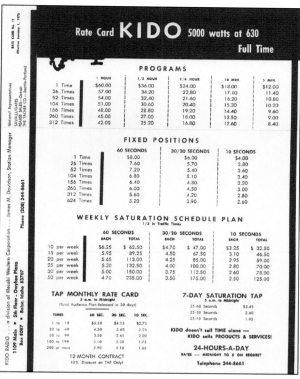

By 1972, Boise's population had grown to 114,300, with over 305,000 people in KIDO's basic coverage area. The number of "radio homes" had increased to almost 97,000 and total retail sales for the market were almost $578 million. (Courtesy of Jack J. Link.)

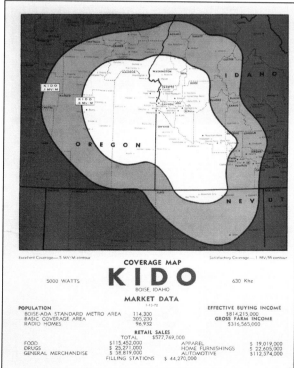

As the 1970s progressed, KIDO took on more of a social conscience and produced some outstanding public affairs programming. Vern Moore's *Probe '72* looked at the increasing teenage drug problem in Ada and Canyon Counties. KIDO also adopted a new slogan, "It's more than just a sound," poking fun at 50,000-watt KBOI-AM, whose slogan was "The *sound* that's all around." (Courtesy of Jack J. Link.)

"OH, STOP YOUR WORRYING. THIS ISN'T NEW YORK CITY... BILLY'S PROBABLY JUST A LITTLE TIRED."

During Golden Sound Week, which took place once a year, KIDO played big band music and old radio shows for one week to celebrate the station's birthday, which was November 5, 1928, the day KFAU became KIDO. This 1971 newspaper ad used the opening lines from the radio drama *The Shadow* and ended with the new KIDO slogan, custom-worded for the occasion, which read, "Even our birthdays are more." (Courtesy of Jack J. Link.)

"Who knows what evil lurks in the hearts of men..."

(come to our birthday party and find out)

Because we're 43 years young tomorrow. And we're going to have a Birthday party. For one week. From Monday, November 8th thru Friday November 12th. We'd like you to meet some old friends. We know you'll remember them. But if by some chance you've never met, only heard their names, let us introduce you. You'll enjoy their company. For they represent the great radio programs of the past. Radio's Golden years of COMEDY, MYSTERY and ADVENTURE. Together with the SONGS, RECORDS and BANDS of yesteryear. And as an added feature, a two hour special: The Golden Big Band Era with hosts Gib Hochstrasser and Lon Dunn.

So whether you remember "Who knows what evil lurks in the hearts of men" or not, give a listen. It'll be a week of radio you won't forget.

KIDO radio 63
even our birthdays are more.

Ernie Allen started at KIDO in 1968 on Vista Avenue, just as plans were being made for the Owyhee Plaza studios. During his time at KIDO, Allen worked virtually every time slot, calling his program *The Allen Affair*. Allen, whose real name was Ernest F. Bovermann II, passed away on January 20, 1993, at age 48. He will long be remembered as one of the nicest and most professional people to ever work for KIDO. (Courtesy of Jack J. Link.)

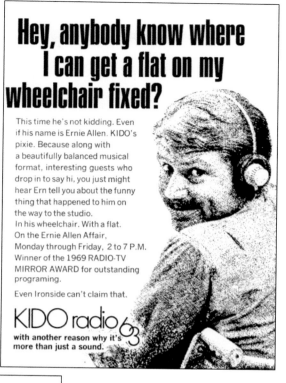

Mike Lesh spent two years as a morning DJ in Nuremberg, Germany, before Lon Dunn hired him in 1969 for mid-day programming. In 1972, he was moved to mornings and stayed until 1975. Lesh was featured in this clever print ad, which asked, "What do you do with a guy who thinks getting up every day at 5:00 a.m. is fun? If his name's Mike Lesh you listen to him." (Courtesy of Jack J. Link.)

Idaho congressman James A. McClure sent this Western Union telegram to KIDO, congratulating the station for its birthday and commending it for its years of high-quality programming and continuous service to the Boise area. (Courtesy of Vern Moore.)

The telegram reads:

IT WOULD BE HARD TO IMAGINE THE TREASURE VALLEY WITHOUT THE CULTURAL CONTRIBUTIONS MADE BY KIDO. WE ARE SO ACCUSTOMED TO THE HIGH QUALITY PROGRAMING THIS STATION PROVIDES THAT WE TAKE FOR GRANTED THE WAY IN WHICH IT ENRICHES OUR DAILY LIVES. HOWEVER, ANNIVERSARIES GIVE US AN OPPORTUNITY TO MAKE AMENDS. SO, LET ME EXTEND BEST WISHES TO KIDO ON ITS BIRTHDAY AS WELL AS A SINCERE THANKS FOR THE SERVICE IT HAS RENDERED TO THE GREATER BOISE AREA.

James A. McClure
Member of Congress

By May 1975, rates in the Boise market had finally reached the double-digit mark, with $10 being the highest rate for 60-second commercials in morning or evening drive times. KIDO was probably the only station left selling one-hour programs, which it offered for $70 per hour. Avery Kodel was still KIDO's national sales representative; however, the John McGuire Company was now representing the station in Denver, and Broadcast Northwest was KIDO's new representative in Seattle and Portland. (Courtesy of Jack J. Link.)

Jack Link was well known to Boise television viewers for his 1970s role as "the man in gold" for Albertson's. In the commercials, Link wore a gold jacket, which was the trademark uniform of an Albertsons store manager. He said that the money he made from doing those commercials helped put his sons, Tim and Ted, through the University of Washington. Lee Johnson coordinated Link's schedule for the ad agency Davies and Rourke. (Courtesy of Jack J. Link.)

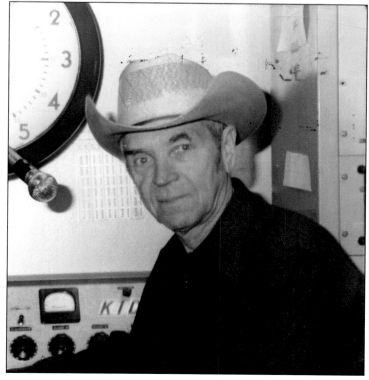

In 1976, Vern Moore celebrated 41 years of nearly continuous employment at KIDO. He only left when he was called to active duty and spent two years on the island of Espiritu in the South Pacific during World War II, and two years in Adak, Alaska, during the Korean War. Upon returning to KIDO in 1952, he never left the station until his final day in April 1977. Thank you, Vern Moore, for all you did for KIDO. (Courtesy of Vern Moore.)

DISCOVER THOUSANDS OF LOCAL HISTORY BOOKS FEATURING MILLIONS OF VINTAGE IMAGES

Arcadia Publishing, the leading local history publisher in the United States, is committed to making history accessible and meaningful through publishing books that celebrate and preserve the heritage of America's people and places.

Find more books like this at
www.arcadiapublishing.com

Search for your hometown history, your old stomping grounds, and even your favorite sports team.